IMAGES
of America

WAUKEE

IMAGES
of America

WAUKEE

Waukee Area Historical Society

ARCADIA
PUBLISHING

Published by Arcadia Publishing
Charleston, South Carolina

Printed in the United States of America

Library of Congress Control Number: 2015930363

For all general information, please contact Arcadia Publishing:
Telephone 843-853-2070
Fax 843-853-0044
E-mail sales@arcadiapublishing.com
For customer service and orders:
Toll-Free 1-888-313-2665

Visit us on the Internet at www.arcadiapublishing.com

This book is dedicated to Paul Huscher and the late Larry Phillips, unofficial Waukee historians. Phillips is quoted in Waukee Today in December 2000 as saying, "We're moving ahead so fast, I want to look back and see where we've come from. In order to go forward you need to know where you come from." His desire for Waukee to have a historical society became a reality in 2012. Huscher was the Waukee city attorney for 42 years and a member of the Waukee Area Historical Society Book Committee.

CONTENTS

Acknowledgments 6

Introduction 7

1. Seeds of Agriculture 11

2. The Early Years 33

3. Coal Mines and Community 49

4. Expansion of Education 69

5. Growth of Waukee 83

6. Hometown Heroes 113

Afterword 125

About the Society 126

About the Museums 127

ACKNOWLEDGMENTS

This book would not be possible without the Images of America: *Waukee* Book Committee, whose members have given their time and resources for this project. A special thank-you goes to the committee team captains, Marcia Blake Mills, Marie Nizzi Kayser, Richard G. Ori, Dena Angaran Forret, Rick Huscher, Sue Ellen Kennedy, and Terry Snyder. We would also like to thank the Waukee Public Library for its resources, the community of Waukee, and the City of Waukee. The Waukee Centennial Committee provided a starting point for this book, and we appreciate its forethought in preserving our early history.

Waukee's Images of America Book Committee members are, from left to right, (first row) Teresa Broderick, Dena Angaran Forret, Paul Huscher, and Terry Snyder; (second row) Rick Huscher, Karen Dluhos, Marie Nizzi Kayser, Sue Ellen Kennedy, Marcia Mills Blake, and Richard Ori. Not pictured is Bruno Andreini. (Courtesy of Terry Snyder.)

INTRODUCTION

In the 1860s, the Walnut Township farmer worked his land by hand and faith. It was a time of simplicity. The life was not easy. When the farmer cleared the prairie grasses, the weather—the heat of summer, seasonal storms, winter cold, or drought—conspired to defeat him. Horses helped greatly with planting and tilling the land. A farmer tended to the crops, which fed his family. Having abundance meant they were able to sell or trade for items needed. Their clothes were handmade, altered, or handed down. Some farmers were able to add cattle, pigs, and chickens to help sustain their families. Every farm had a spring vegetable garden. Some added apple orchards, and these groves helped provide much-needed windbreaks, which helped keep the topsoil from blowing away. Caves, or what could be called cellars, were used to store apples. They also served as shelter for the families during bad weather events, such as a thunderstorms or tornadoes. The entire family worked on the farm. Children often missed school during the harvest and when family members were ill or had died. Eventually, innovation and mechanism took the place of horsepower on the farm. A puffing steam engine was a sight. Threshing required preparation and teamwork, and crews of 30 men were sometimes needed. While the threshing team worked, the mothers, wives, and daughters would be undertaking food preparation in the house. There are still some multiple-generation-owned family farms near and in Waukee.

In 1869, the Des Moines Valley Railroad decided it would move west through Walnut Township. Gen. L.A. Grant and Maj. William Ragan, owners of a real estate business, bought the land around the railroad bed from Cyrus W. Fisher on April 30, 1869, and 320 acres were laid off in lots for homes and businesses. Now, with the railroad tracks and depot completed, the farmers were able to ship their farm products by rail to Des Moines. The post office in Waukee was established on September 20, 1869. In June 1878, Judge Callvert appointed M. Sines, B.T. Halstead, C.C Tyler, C.F.M. Clarke, and G.S. Wharton as commissioners to hold an election for incorporation, according to the *Dallas Center Globe*. They designated July 2, 1878, as Election Day. The election was a success, with 35 votes for and 15 against. The first election of officers for Waukee was held on July 24, 1878. Elected to office were Mayor T.F. Howe, recorder W. E. Humphrey, town council; A.T. Blackman, C.C. Tyler, Pat Hogan, C.F.M. Clarke, W.H. Wood, Taylor Bates, and assessor John A. Houston. The council held its first meeting after qualifying and passed its first ordinance by unanimous vote—Ordinance No.1: the sale of spirituous or vinous liquors was prohibited within two miles of the corporate limits of Waukee. In the 1900s, Waukee had two railroads with passenger service, two depots, mail service, and telephones in town. The downtown Triangle was surrounded by various businesses, including Crispin & Duncan General Store, J.H. Carter Hardware and Implements, George T. McMahon and Dr. Alfred Price Physicians, Waukee Savings Bank, and Brenton Bank. There was also a hotel, drugstore, barbershop, and a restaurant. The Farmer Elevator Company was established and is still in business.

In 1920, the Harris Mine opened. It was located 2.5 miles from Waukee. About 100 families lived south of the mine, which closed in 1928. In 1921, the Shuler Company started its mine one mile east of the Harris Mine. It employed 500 men. These men were assisted by 32 mules. The

work was very physical in the 387-foot shaft with its underground tunnels. The rooms were very dark, lighted only by carbide lamps, and were also damp and silent. In 1941, mechanical loaders were installed along with strings of electrical lights. The miners faced many dangers daily. This mine took out over seven million tons of coal in 28 years of operation. Three camp communities surrounded the mine, and families were raised with tradition, faith, and a sense of community. The mining camp had a grocery store, school, bar, and restaurants. The Shuler Mine closed in May 1949; owners could no longer afford to bring the coal up to the surface from three or four miles of underground rooms and tunnels. Today, Shuler Elementary stands across from the former mining area in recognition of the once thriving mine.

The Presbyterian church was built in 1870. At this time, Waukee had only three school-age children—Hattie Blackman, Lulu Colbart, and Fannie Burke. The first school was held in the Presbyterian church for about three years. The first teacher was a Miss Spear from Buffalo, New York. The first school building was erected in Waukee in or around 1874. It was a two-story, 26-by-40-foot structure, constructed at the cost of $2,300 and consisting of two good schoolrooms and two recitation rooms.

In 1879, Waukee was an independent school district with a school board. Members of the school board were A.T. Blackman, C.F.M. Clarke, C. Tyler, and George M. Bass. A.C. Phillips was the principal, and Sara Randall was the primary teacher. The average attendance was 85 pupils at that time. By 1901, the school population had outgrown the facilities, and the Presbyterian church was used temporarily for a schoolroom. A large four-room brick building was erected. It cost $6,000 and was located in the northeast corner of the block occupied by the present structure. This building was divided into four sections—primary, intermediate, grammar, and high school. The high school only consisted of two grades.

On July 6, 1915, the first election to consolidate the Waukee School was held. The votes from the city were 36 in favor, 25 against, and those from rural districts were 25 in favor, 79 against. The next year, a second election was held on July 21, 1916. This time, consolidation of the country schools and Waukee School passed by a large majority, City votes were 76 in favor and 14 opposed, and rural votes were 60 in favor, 36 opposed. In 1916, another school building was needed, and the course of study was expanded to a four-year high school. The next step was to select a type of school bus. No roads were surfaced, and mud roads required something sturdy. Drivers with reliable teams of horses had to be hired, teaching staff had to be chosen, and a superintendent who was familiar with the problems of consolidation also had to be selected.

There were very few schools consolidated in Iowa in 1916–1917, but the school board working with Miss Forgave and the State Department of Public Instruction had made a thorough study of all schools already in operation. It is believed that Superior in Dickenson County near Spirit Lake was one of the earliest consolidated schools. This school system became a model for other schools in the process of consolidation. The school board wanted the current superintendent of Superior School, whose experience would be valuable in establishing the new school. An offer was made to then superior superintendent J.W. Radebaugh, along with his principal and English teacher, Luella Kettleson. After agreeing to substantial salary increases, they signed contracts. With the war in Europe, construction of the new school building was delayed. In September 1916, lessons were held in improvised classrooms all over Waukee. The new Waukee Community School—now the Vince Meyer Learning Center—was completed by the end of 1917 and was occupied on January 1, 1918. Enrollment in the fall of 1968 was a total of 796 pupils.

In 1973, Waukee's first high school building was erected. It is now Waukee Middle School. The Waukee School District remained small well into the late 1980s. In 1994, it served slightly more than 1,100 students and had a graduating class that spring of 68. A new high school opened in the fall of 1997. This facility has seen many additions, including the latest one finished in 2013. Beginning with the 2001–2002 school year, the district has grown by at least 280 students per year, making it the fastest-growing school district in Iowa.

Current enrollment is almost 8,600, with a senior class of 450 students and a kindergarten class of almost 850. There soon will be 15 school buildings in Waukee, including 9 elementary schools.

In the fall of 2016, a Center for Advanced Professional Studies will open, giving students more opportunities. The Waukee district boundaries include Waukee, portions of West Des Moines, Clive, and Urbandale.

With this growth, various new businesses began, and the need for new churches was addressed. New subdivisions were planned, approved, and developed, and new lots were recorded with Dallas County. The lots were purchased, and new single-family homes were constructed. New strip malls have been built on Hickman Road. The business area for many years surrounded the historic Triangle, and now the focus has been moving to Hickman Road and University Avenue. The population in Waukee has been constantly growing for many years, with Waukee being the fastest-growing community in Iowa. The population in 1880 was 245; in 1910, it had increased to 340. In 1994, the population of Waukee was 3,411, and in 2004, it had reached 8,132. The 2010 census data states that the population was 13,790. On May 22, 2014, the US Census Bureau released data that the population had increased 22.22 percent from 2013 data, and as of May 2014, the population was estimated at 17,077.

The Triangle is the center of downtown. A variety of music events are held there, including Jazz in July and the Art Central music series every June. The Waukee Farmers Market is held there on Wednesday evenings every summer. Celebrate Waukee and Winter Festival activities are held every year. Unfortunately, many of the old buildings that once stood down at the Triangle are gone, including the railroad depot. The Waukee State Bank building still stands, and the Heartland Co-op (Farmers Co-op) is still in business. Chops, a bar, is located in the old bank. The barbershop still in business, having had only two owners, and the Banks law firm is in the old hotel. The community's Centennial Park is the location for the annual Easter egg hunt and Fourth of July celebrations.

On February 22, 2009, the Manders Museum, an addition to the Waukee Public Library, was opened. The museum showcases information and items from Harold C. "Hal" Manders, a Waukee resident who played professional baseball in the 1930s and 1940s. In 2011, the Waukee Public Library received a generous bequest from former resident Hiram Ori. The bequest, made in loving memory of Hiram's parents, Ernest and Casimira Ori, was for an addition to the library for a coal mine museum and a meeting room. The Ori Coal Mine Museum and Coal Mine Meeting Room were completed in 2013. Waukee has several bike and walking trails and is connected to the Raccoon Valley Bike Trail.

Civil War veterans moved west to the community, bringing dreams and pride, and there are several Civil War veterans buried in Waukee Cemetery. World War I came and shocked the world, and things would never be the same. As in all wars, brave men and women sacrificed. There were war bond drives, Red Cross appeals, and strict food and clothing rations. Then, on November 11, 1918, an armistice was signed between Germany and the Allies. On December 7, 1941, the nation was shocked again when Pearl Harbor was attacked by Japan, bringing the United States into World War II. Waukee's young were off to war in Europe and other areas of the world, and the community came together for one another. American involvement in World War II lasted from 1941 to 1945, and the Korean War began in 1950 and ended in 1953. Today, many of Waukee's young adults voluntarily sign up for the armed forces to serve and protect our nation.

Thankfully, the community has maintained a small-town atmosphere and adapted well to the challenges that came along with growth. City leaders have taken steps to ensure a smooth transition, with proper planning and community development. Many citizens have been involved in a variety of ways. Convenience has been an advantage with growth of commerce. In town, jobs cut down travel, and a selection of goods and services make life much easier. Waukee is the key to good living.

One

SEEDS OF AGRICULTURE

Settlers started coming into Dallas County in 1837. There were no roads, railroads, bridges, churches, or houses, only fertile land covered by prairie grasses and swampy areas. Many were farmers from Indiana or Ohio. In 1847, when the area was finally opened for settlers, 75 persons lived in Dallas County, mainly south of and west of Waukee. Thus, before the town of Waukee existed, farms began to sprout up around the area. Settlers came with few tools, a team of horses, and a lot of faith in the promise of a future. These early farm families relied on each other for their existence. As they came, they built simple cabins, followed by barns for their livestock. They planted windbreaks, dug wells by hand, and dug storm caves to store produce over the winter and to protect themselves from tornadoes. With the advent of the town of Waukee and the railroad, farmers could sell their crops locally, shop for necessities, and transport their crops and livestock to market without needing to travel several days. The pioneers grew large vegetable gardens to supply their needs for the entire year, as they could not buy produce at the local market.

The Industrial Revolution spilled over to the farm with new mechanized methods, which increased production rates. Early on, the large changes were in the use of new farm implements. These early implements were still powered by horse or oxen. The advent of steam-powered and, later, gas-powered engines brought a new dimension to the production of crops. In the 1930s, rubber-tired tractors with complementary machinery came into wide use to accommodate growing demands. As land prices and production costs increased, and livestock prices decreased, it became necessary to find methods to grow crops and livestock at the lowest cost possible. Between 1940 and 1970, changes from horses to tractors and the adoption of technological practices characterized the second American agricultural revolution. Beginning in the 1980s, farmers began using low-till methods to curb erosion. Farming is seasonally dependent; thus, this chapter attempts to show changes in agricultural practices over time by season.

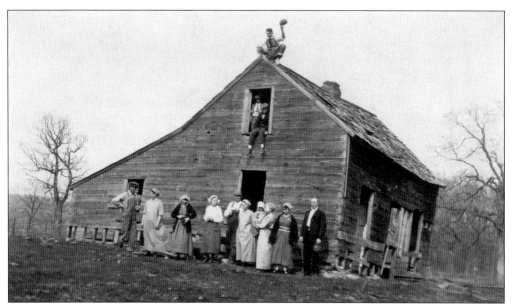

The Blake family is pictured in 1916, sitting in the cabin built by their family in 1856 just north of Waukee and close to the water supply of Walnut Creek. This cabin, typical of those erected by early settlers, had a single fireplace and sleeping quarters in the lean-to and upstairs. Cabins were built for several families to survive the first tough winter (Courtesy of Marcia Blake Mills.)

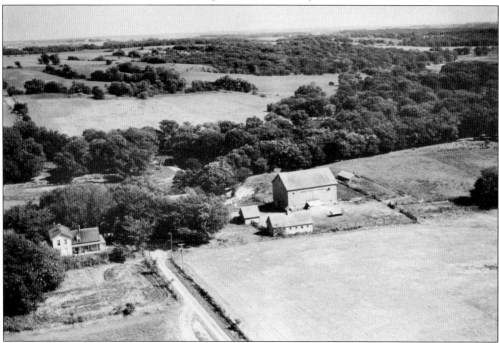

Henry Young's homestead was established in 1862. Henry was an early settler of Walnut Township from Prussia; his wife, Elizabeth (Betz), from Baden-Wuerttemberg, settled with her brother John's family in Walnut Township in 1856. Every building on the farmstead served a purpose. The bank barn allowed a team to pull into the upper level to unload hay, while stalls for animals were in the lower level of the structure. (Courtesy of Marcia Blake Mills.)

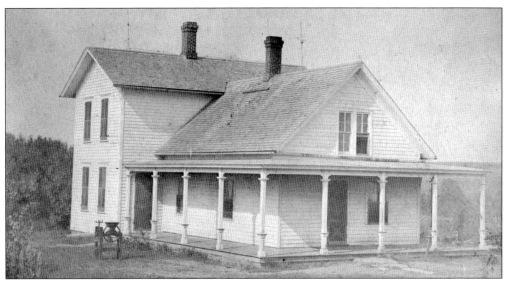

Henry Young's home was also built in 1862 in Section 24 of Walnut Township; families typically built a small cabin. Later, a larger home or addition was constructed as needs grew. Henry would take his pitcher to fill it from his keg of German beer in the cellar under the far side of the house. Note the cider press next to the house. (Courtesy of Marcia Blake Mills.)

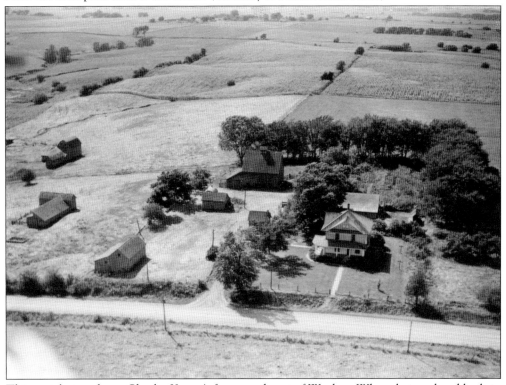

This aerial view shows Charles Young's farm northeast of Waukee. When designed and built in 1911, it resembled a small town; each outbuilding had a specific function. The property included a smokehouse, a buggy shed, chicken coops for broilers and hens, horse and dairy barn, hog sheds, a granary, and a hay barn. (Courtesy of Marcia Blake Mills.)

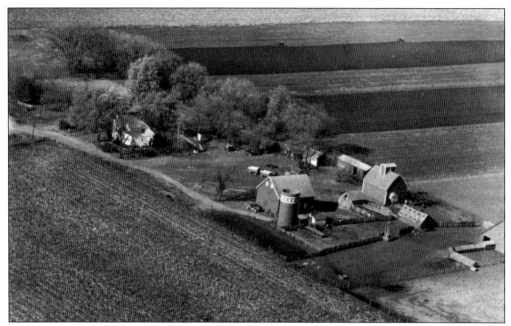

The Forret Farm in Van Meter Township southwest of Waukee is pictured here. Butchering of livestock was a wintertime chore, and it could be said that farm families wasted nothing. Everything on a hog was used. Fat was rendered into lard over large kettles, and crackling was made from pigs' skin and deep fried in lard. Sausages were stuffed into intestines, and everything else was canned or cured in the smokehouse. (Courtesy of Francis Forret.)

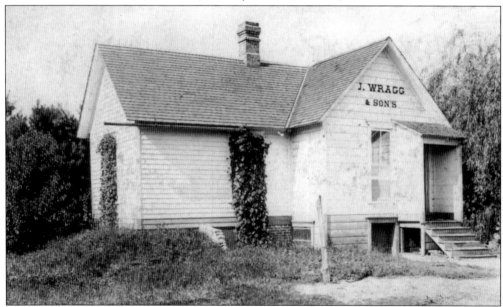

John and Hannah (McManus) Wragg moved to Section 5 Boone Township in 1863. Within a few years, John gave up farming to focus on horticulture. In 1878, the Wraggs began devoting their attention to the cultivation of flowers, fruit, and ornamental trees. Seeds, fruit trees, and shade trees were important to the settlers in establishing their homesteads and feeding their families. (Courtesy of JoAnne Hinkson David.)

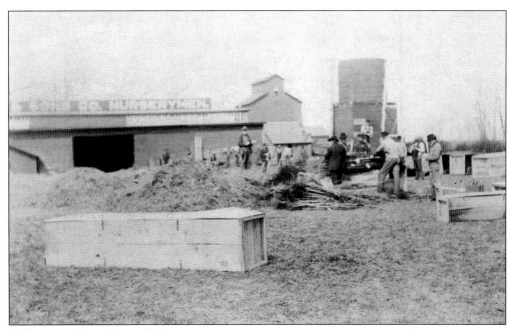

J. Wragg and Sons Central Nurseries was established around 1900. Newton and Morris Wragg purchased land near the two railroads on the north side of Waukee to support the growing business they had taken over from their father. Morris managed an Iowa Experiment Station on the nursery grounds. He was president of the State Horticultural Society and a member of the State Board of Agriculture. (Courtesy JoAnne Hinkson David.)

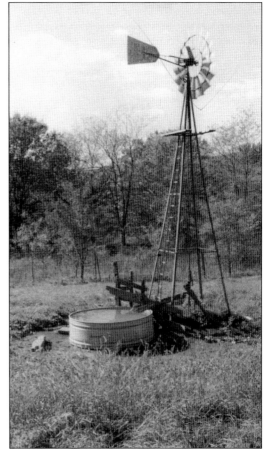

Windmills were a mainstay on farms to pump water for livestock tanks. Early settlers tended to build near water supplies such as a creek. However, as more farms were established away from these water sources, access to water was an issue. Large steel windmills were installed that could pump water from deep wells. (Courtesy of Phil Broderick.)

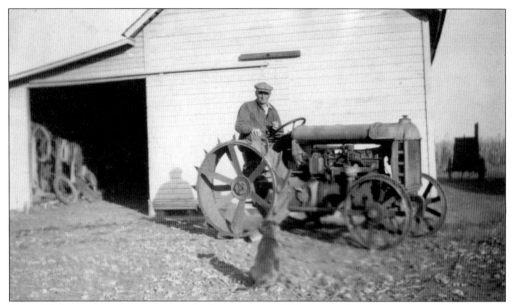

Baker Blake is riding his tractor at the farm north of Waukee in this 1914 image. After the turn of the century, horsepower was slowly replaced with mechanization. World War I required farmers to increase production, which could not be done using only horses. Livestock pedigrees were improving, new farming methods were adopted, fields were drained using tiles, and improved seeds for better yields were introduced. (Courtesy of Marcia Blake Mills.)

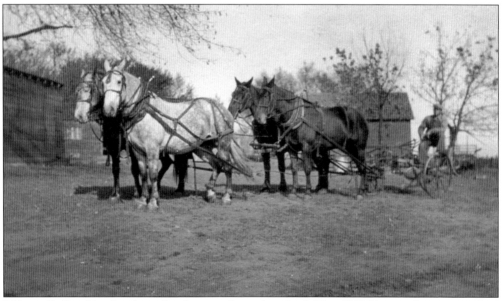

Milvern Boll and his four-horse hitch are ready to plow the field in 1917. Despite the movement to mechanization, some tasks were still completed with horses. Anywhere from two to eight horses might be hitched to an implement, depending on how hard the task was for the horses. Larger, draft-style horses were needed for heavy pulling. (Courtesy of Marcia Blake Mills.)

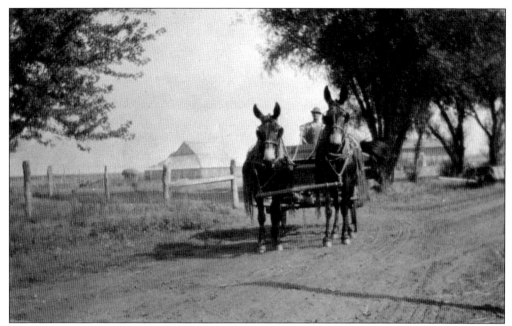

Baker Blake is driving a team of mules near his farm two miles north of Waukee in the 1920s. Mules ate less than the large draft horses; thus, they were often used in the field and around the farm for lighter duties. Heavy tasks such as plowing were done by the draft horses. Note that the road is merely a dirt path. This is now Meredith Road. (Courtesy of Marcia Blake Mills.)

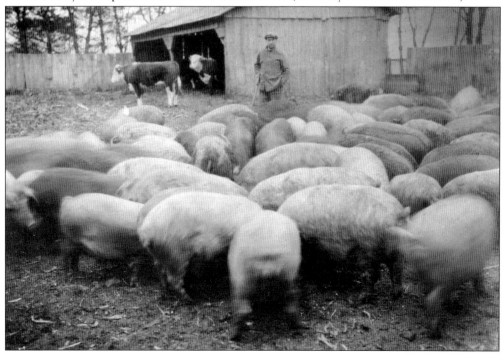

Baker Blake's livestock was fed by hand. In addition to grains, hogs were often fed kitchen scraps or leftover milk. After the crops were harvested in the fall, they were often turned out to scrounge for food, adding fertilizer to the fields. (Courtesy of Marcia Blake Mills.)

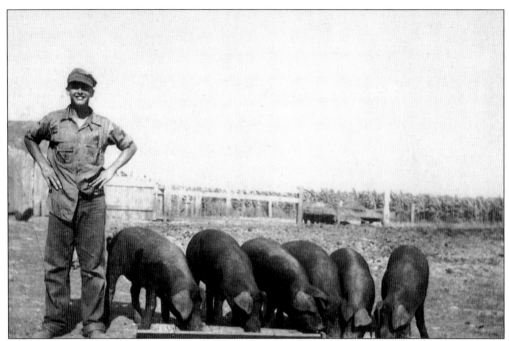

Bob Copeland is feeding the hogs at his family's farm around 1940. Not much has changed from previous times. Hogs were still fed in the feedlot and let out to scavenge for corn among the corn stocks in the winter. As land prices and production costs increased, and livestock prices decreased, it became necessary to find methods to raise cattle and hogs faster and cheaper. (Courtesy of Carol Copeland Geib.)

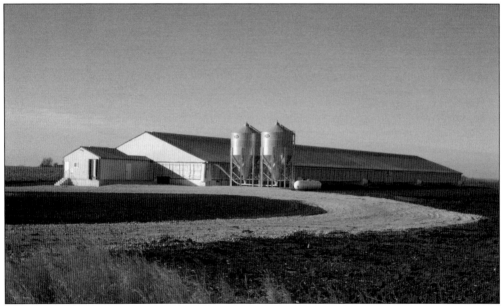

The need to raise livestock more efficiently resulted first in the rise of high-production feedlots for hogs or cattle, and then confinement systems such as Fox Farm's new hog facility in Walnut Township. The liquid manure, stored under the facility, is used to fertilize crops in the spring. (Courtesy of Marcia Blake Mills.)

Baby chickens were raised in the field with the hens. Hatching eggs were either harvested from the chickens or ordered from another farm. When unhatched eggs arrived at a farm, they were placed under a broody hen or in an incubator to be hatched. Chicks were often lost to predators, as hawks or owls would swoop down and grab a defenseless chick before the hen could put up a fight. (Courtesy of Marcia Blake Mills.)

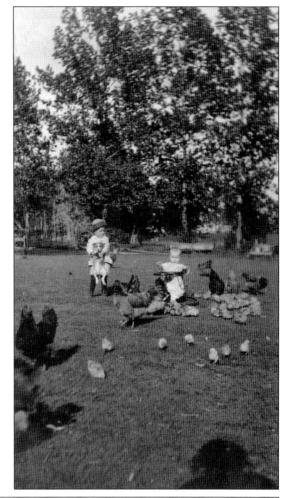

June (Smith) Blake and her chickens are pictured here in 1947. Brooder chickens were often raised on pasture. Chickens were vulnerable to attacks from hawks, as well as four-legged animals. Eggs were gathered and taken to town. They were stacked in large cartons to be delivered to the dealer in Des Moines. Earlier generations would take their eggs to Waukee or take the train to Des Moines to sell or trade for supplies. (Courtesy of Marcia Blake Mills.)

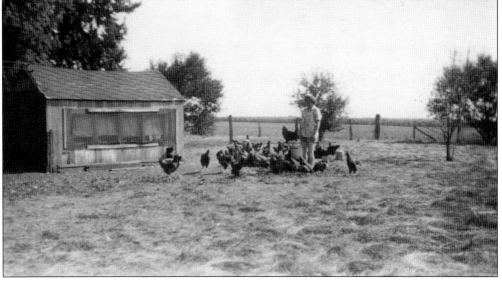

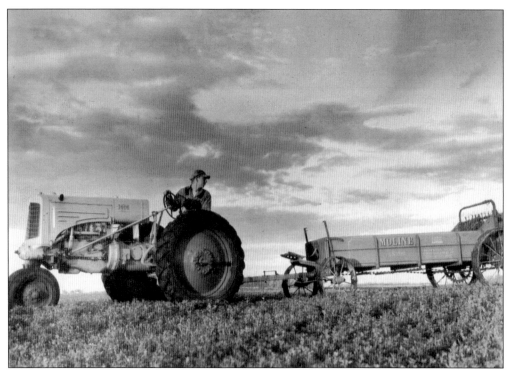

Bob Copeland and his Minneapolis Moline manure spreader appeared in *Wallace Farmer* magazine. In the spring, farmers cleaned out their lots, barns, and chicken coops, loading the manure to be spread over the field, composted in the soil, and disked into the soil before planting. Oats, a major crop, were the fuel of horses, sown as soon as the ground could be worked. (Courtesy of Carol Copeland Geib.)

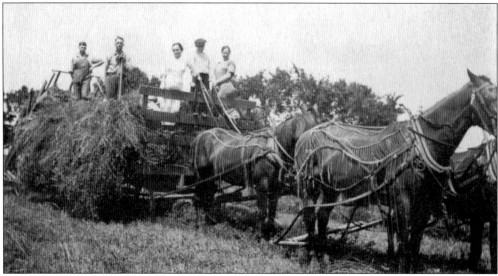

Haying is under way at Homer Boll's in this 1918 photograph taken by Clara (Blake) Boll. Hay was raked and picked up by the pile to be lifted into the barn to feed the livestock in the winter. Pictured are, from left to right, Baker and Ilma (Boll) Blake and daughter Leona, along with Milvern Boll, Elmer Boll, and Homer and Nina (Poessnecker) Boll. (Courtesy of Marcia Blake Mills.)

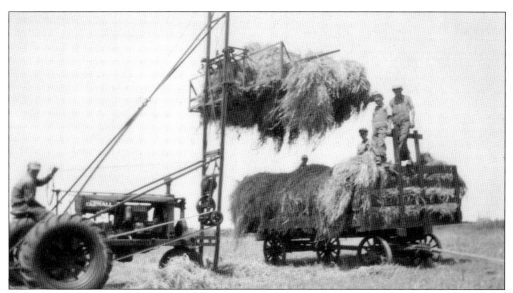

Haying became easier on Carl Smith's farm when tractors were used to pick up the hay and put it on the hay wagon. The loaded wagon was driven to the barn, and the haymow door was opened to allow the large hay fork to drop into the load of hay. (Courtesy of Marcia Blake Mills.)

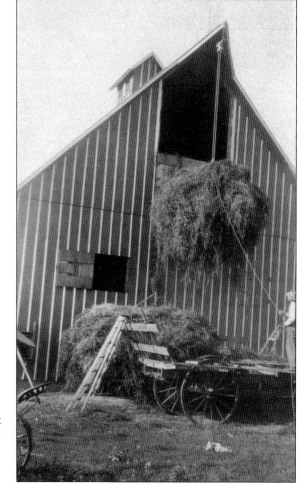

The hay was lifted into Charles Young's barn using a pulley system attached to the beam of the haymow. A large hook attached to the pulley picked up bunches of hay. The hayfork was attached to ropes and pulleys that allowed the load to be pulled into the haymow by manpower or horsepower. (Courtesy of Marcia Blake Mills.)

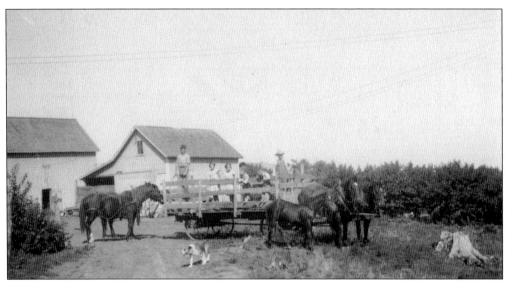

Carl Smith and children—from left to right, Ronald, June, Catherine, Verle, and Lyle—are posing on a hayrack in this 1935 photograph. Farm life involved the entire family pitching together to get things done. Colts of hitch mares ran alongside their mothers in the field, either tied to the mare or loose. Children were often responsible for gathering eggs, feeding livestock, and helping in the garden. They would also take refreshments to the men working in the field. (Courtesy of Marcia Blake Mills.)

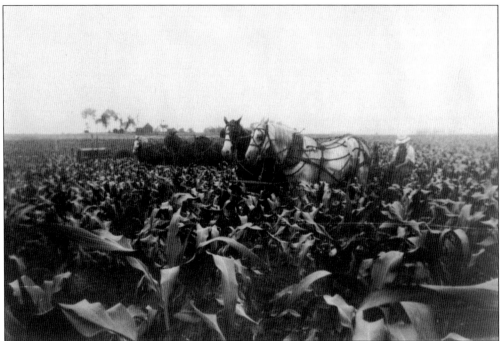

As the corn grew taller, it became necessary to remove the weeds from the rows. Note the tractor at work next to the teams. Weeds in the rows made it impossible for horses or tractors to navigate at harvest time; they would also clog early harvest equipment, causing time lost. (Courtesy of Marcia Blake Mills.)

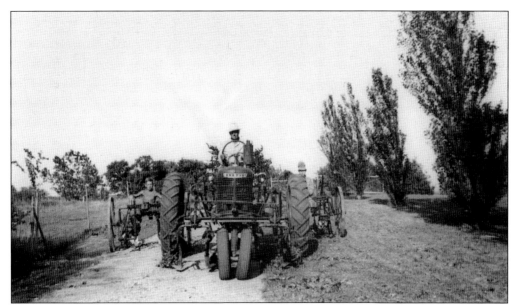

Carl Smith is accompanied by his sons Lyle (left) and Verle (right) with their cultivator. The Smiths were always thinking of new ways to do what was needed. In this instance, they welded extra pieces of cultivators together so the boys could pull weeds growing in the row while sitting down. This kept the fields clean of weeds without requiring that they walk through the fields. (Courtesy of Marcia Blake Mills.)

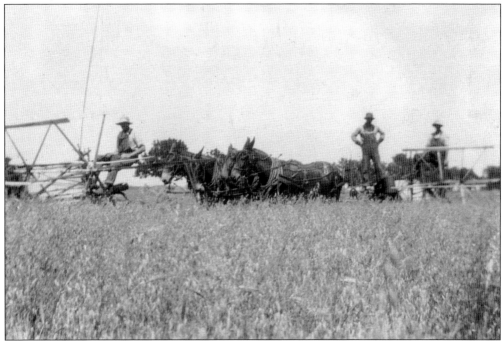

In this image, oats are bound to be shocked later. The binder cut and tied the oats, which were then left in the field to dry. After the shocked oats were dried, they were loaded onto a wagon and taken to the threshing machine. Threshing removes the oats from the stalk to be fed to the livestock. (Courtesy of Marcia Blake Mills.)

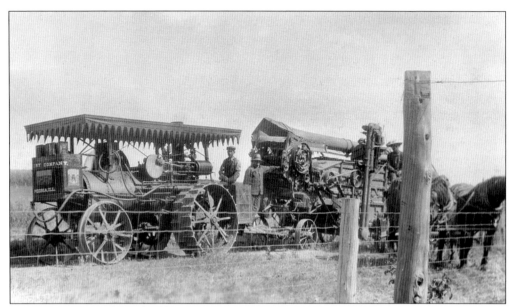

Early threshing machines had huge steam engines. They moved from farm to farm, with the crew moving with them. Sometimes, the machines would stay in one spot, with oats from adjoining farms being brought to them. Neighbors worked together to get everyone's oats threshed. Even small children helped. They drove teams of horses, helped prepare meals, or brought water and snacks to the crew. This threshing crew was documented in 1914. (Courtesy of Marcia Blake Mills.)

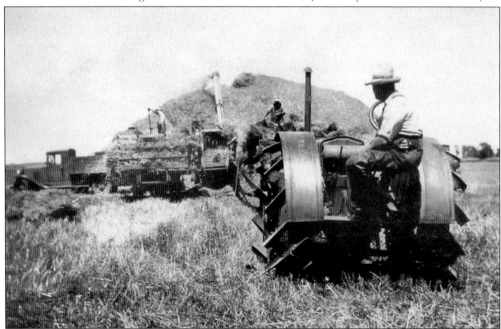

Milvern Boll (left) and Baker Blake (right) are loading shocks of oats from the wagon into the thresher machine. The tractor in front ran the thresher on a belt. As machines became less expensive and easier to use, it took fewer men to run them. What had previously taken up to 30 men could now be accomplished with a few. The man pictured in the center is unidentified. (Courtesy of Marcia Blake Mills.)

The threshing season was a time of activity and preparation. A large crew of men was needed to run all the machines and teams. Crews were made up of family members and neighbors, with labor exchanged as the steam engine moved from farm to farm. At the same time, the women worked hard putting together meals for the workers. Tables in the yard overflowed with food. (Courtesy of Marcia Blake Mills.)

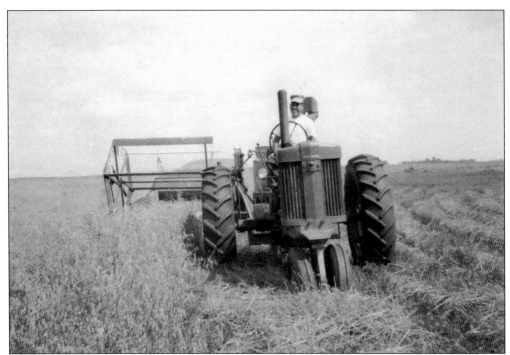

Verle Blake is combining oats in his field two miles north of Waukee in 1962. Combines replaced threshers. The combine separated the oats from the chaff. When the oats were separated from the stocks, the stocks were laid down on the ground, and the chaff was blown out the back of the combine. Later, the stocks were raked, windrowed, and then baled as straw for livestock bedding. (Courtesy of Marcia Blake Mills.)

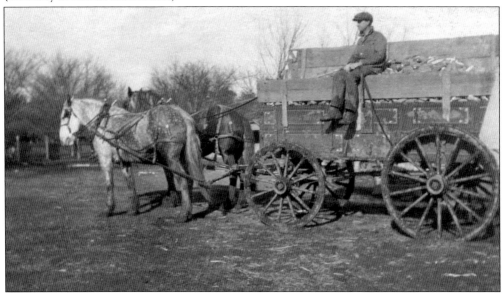

Before there were machines to pick corn, it was done by hand. Ears were picked and thrown into the wagon by people walking beside it. The higher side on the wagon prevented the corn from being lost over the far side. After the corn was shucked, the cobs were used as bedding for livestock or were burned in the woodstove. (Courtesy of Marcia Blake Mills.)

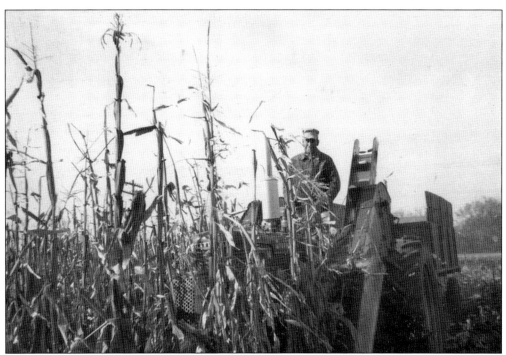

Verle Blake is pictured picking corn north of Waukee around 1960. As the number of acres planted increased, it was not feasible to pick corn by hand any longer. Corn pickers, designed to fit over the tractor, allowed two rows to be picked at once. The picker took the ears off the stalk as it went up a conveyer belt and fell into the wagon pulled behind the tractor. (Courtesy of Marcia Blake Mills.)

Lyle Smith is pictured on his combine loading corn onto a truck to be taken to either the elevator or his on-farm grain bins. As yields increased, trucks, rather than wagons, were used to haul grain, and greater demands were put on elevators to keep up with the demands for grain storage. (Courtesy of Marcia Blake Mills.)

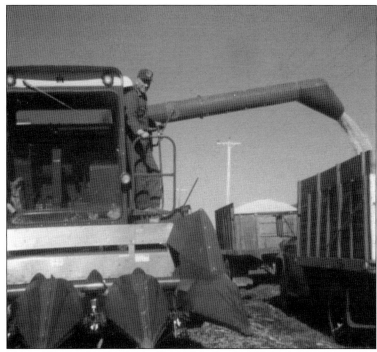

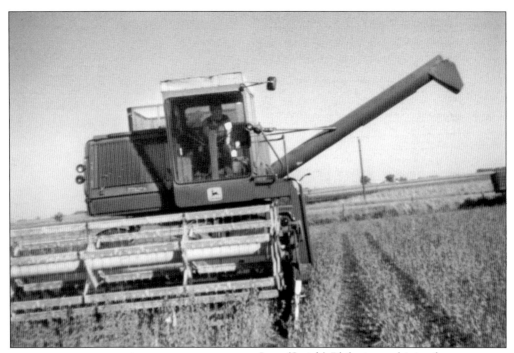

June (Smith) Blake is combining beans at a field three miles north of Waukee. Verle and June worked several farms that were in the family for over 100 years. June loved to drive the combine, while Verle drove the corn, delivering the load to the elevator in town for storage. (Courtesy of Marcia Blake Mills.)

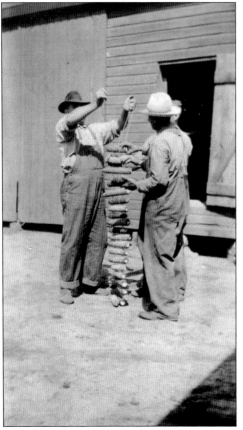

Baker Blake (left), Clarence Boll (center), and Milvern Boll string up seed corn in the fall of 1918 to plant in the spring. Corn was used for silage (cut when still green for livestock feed) or was picked by hand and stored in the corn bin until it was ground up for feed. The best grain was saved to be planted as the crop the following year. (Courtesy of Marcia Blake Mills.)

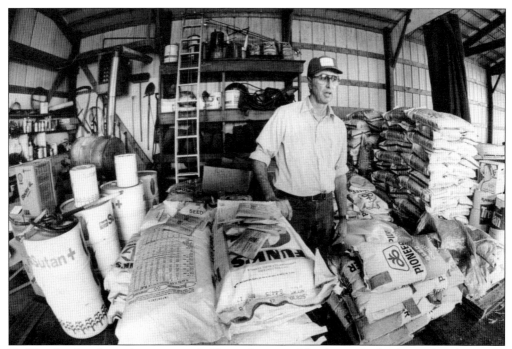

Phil Broderick is shown here surrounded by seed corn and fertilizers. As the demand to plant more acres grew, it became necessary to rely on seed companies for seed. These companies, through research and trials, develop new breeds of seed that produce higher yields and were more immune to common diseases; thus, they improved seed for better yields. (Courtesy of Phil Broderick.)

Alonzo Copeland was a charter member and director of the Waukee Co-Op and also farmed east of Waukee. The Waukee Farmers Co-Op formed in the early 1900s to provide area farmers a place to market their grain for a fair price. Through the years, it evolved as farming methods and needs changed. The co-op strived to give area farmers a voice in the future of agriculture. (Courtesy of Carol Copeland Geib.)

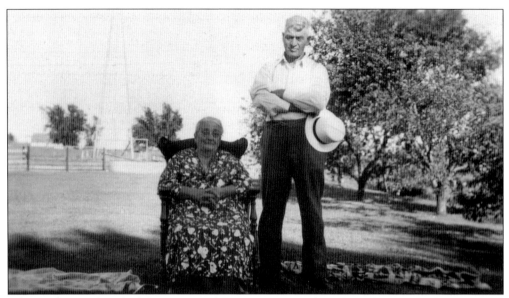

Bert and Cora (Thorn) Blake were noted for superior Barred Rock chickens, Poland China hogs, and Black Angus cattle their sons showed nationwide. Bert, along with his brothers, also owned a restaurant and meat market in Waukee. In 1941, the Blake brothers showed the grand champion heifer at the Chicago Livestock Show. (Courtesy of Marcia Blake Mills.)

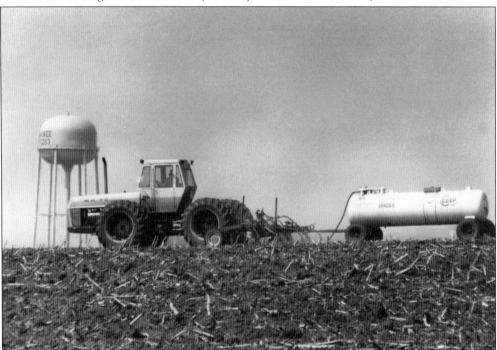

Tim Broderick is spreading anhydrous ammonia on his field. Anhydrous ammonia is an available and efficient source of nitrogen fertilizer. Because it boils at negative 28 degrees Fahrenheit, is caustic, and can cause severe chemical burns, it must be kept under pressure and stored as a liquid above this temperature. Anhydrous ammonia expands into a gas as it is injected into the soil, where it rapidly combines with soil moisture. (Courtesy of Phil Broderick.)

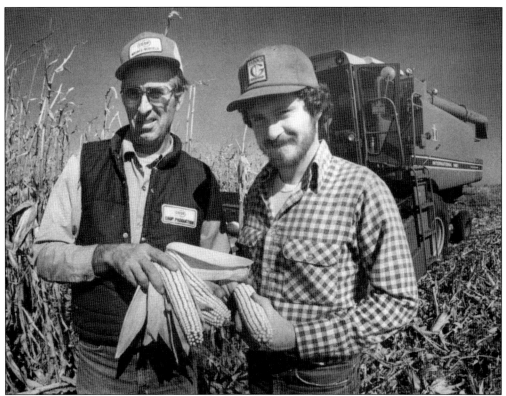

Phil (left) and Tim Broderick are pictured checking their corn yield. Since taking over farming responsibilities from his dad, Tim has been the fourth generation of Broderick to work their farm on the north edge of Waukee. Technology has enabled the production of corn that is more resistant to pests, has higher yields, and can be planted in narrower rows. (Courtesy of Phil Broderick.)

Phil and Tim Broderick prepare the ground for seeding. Throughout history, farmers plowed their fields to plant crops. However, as soil erosion became an environmental problem, soil preparation changed. Beginning in the 1980s, farmers attempted to reduce soil erosion caused by plowing and tillage, which had been key factors behind the Dust Bowl of the 1930s. New tillage tools mix residue with soil to speed up the decomposition of corn. (Courtesy of Phil Broderick.)

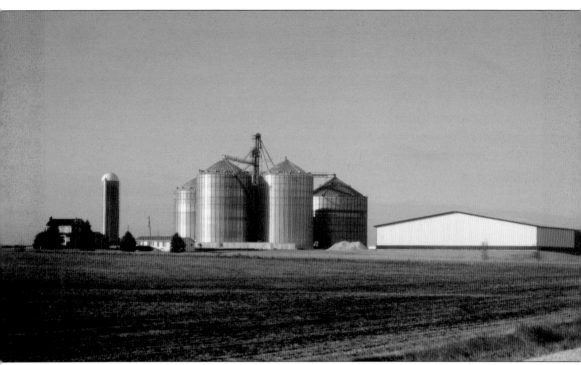

Fox Farm, two miles north of Waukee, is an example of the shift to high-production, large-acreage farms focused on grain production and away from smaller family farms that include several types of livestock as well as grain. Note the large grain-drying bins. Large equipment storage buildings have replaced barns and provide a place to work on the equipment and store it protected from the elements. (Courtesy of Marcia Blake Mills.)

Two

THE EARLY YEARS

Waukee, for most of its history, has been a small town. The 1880 population was 245. The business district consisted mostly of the buildings facing the town Triangle and the one block south. A fire in 1893, beginning in the Garlock butcher shop, destroyed T.F. Howe's general store, the post office, a warehouse, and C.F.M. Clarke's drugstore. The stores were rebuilt, but in 1901, another fire, which started in the hayloft of Spencer Smith's livery stable, destroyed the entire north side of the Triangle, including the Brenton Brothers Lumber Yard, J.H. Carter's implement and hardware store, T.F. Howe's building, L.L. Staver's restaurant, the Waukee Advocate printing office, John Shaw's shoe shop, and A.J. Bassler's building and furniture stock. The town's first fire truck was purchased in 1938. Delivery of the fire truck was made the day after fire destroyed the Morrill Drug Store on the west side of the Triangle. While the building was still smoldering, the new fire truck was sitting across the street.

In January 1941, the Brumfield Building, on the west side of the Triangle, caught fire and was destroyed. The building, on the corner of Sixth and Walnut Streets where the hardware store stands now, housed the post office, the telephone exchange, the library, the Sam Hurwitz grocery, and four apartments. Its loss left only A.D. Linn's barbershop on the west side of the Triangle. The area sat vacant for almost 20 years before the Uptown Café and the hardware store were built.

Through fires, changes in ownership of businesses, deaths of prominent citizens, the influx of miners and newcomers, and the constant advancements in agriculture, the community survived and built a reputation as a great small town in which to live, work, and raise families.

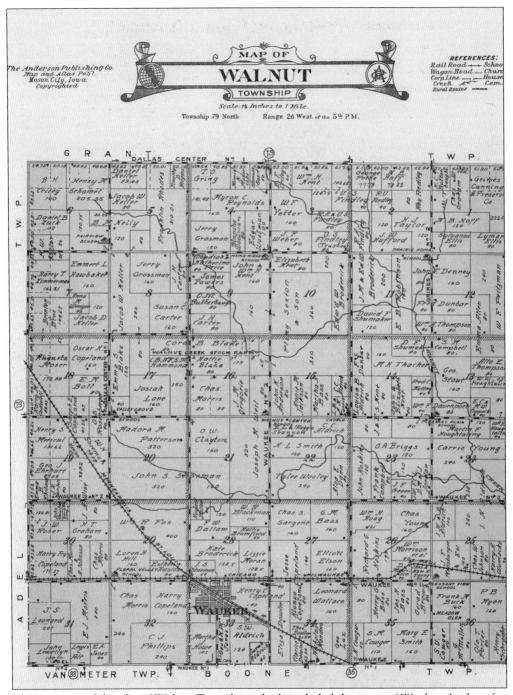

This is a copy of the plat of Walnut Township, which included the town of Waukee. It identifies the family names for land owned in and around Waukee at that time. Some families still reside at or own these properties. (Courtesy of Dallas County recorder Chad Airhart.)

One of the founders of Waukee was Gen. Lewis A. Grant. General Grant came to Des Moines after the Civil War ended and joined the speculative real estate business with Maj. William Ragan. In 1869, while the railroad was being laid to Waukee, they purchased the land in Walnut Township on which the town of Waukee would be built. They originally called the town Shirley, but the name was changed to Waukee after they received pressure from the railroad company. General Grant and his family never lived in Waukee; he did, however, buy some houses to promote sales and growth of the town. After living in Des Moines for 20 years, his family relocated to Minneapolis. (Courtesy of the City of Waukee.)

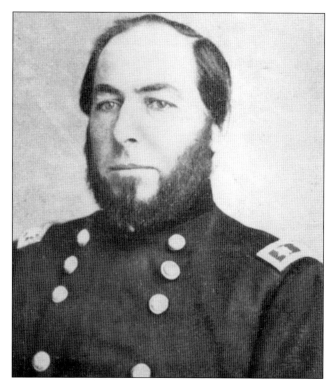

Betsey Morrison Snow was born in Groton, Vermont, in 1844. At an early age, she decided to travel to Iowa to join her brother Bradley and his family. In 1864, she moved to Snow Settlement in Walnut Township with her sisters Harriett and Maria and their families. In 1865, Betsey married Andrew Snow, who had also joined his family at the Snow Settlement, having been born in Pennsylvania in 1829. Andrew and Betsey moved to Waukee in 1869 and set up their grocery store. They had two sons, Morrison and Freeman. Freeman was the first boy born in Waukee. (Courtesy of Marcia Blake Mills.)

Betsey (left) had the first plastered walls in Waukee. When Andrew died in 1877, she continued in the grocery business. She was a charter member of the Presbyterian church, and half a century later, she was the only surviving charter member present to celebrate the 50th anniversary. She lived a long, busy life, dying at age 97. At times, sister-in-law Julia Snow or sister Maria (pictured here with Betsey) lived with her. (Courtesy of Marcia Blake Mills.)

Clark and Mary (Schaeffer) Smith appear in this wedding photograph from 1865. They settled on a farm east of Waukee and, later, Clark had a grain mill and a lumberyard in town. The Smith family was represented in Waukee early in its existence. Brothers Clark and Spencer Smith were originally from Ontario, Canada. In 1861, at ages 14 and 18, they ventured south to float logs down the Chippewa River in Wisconsin. On one of their trips, they met two sisters, Mary and Martha Schaeffer. The couples married and moved to Waukee. Clark and Mary settled in Walnut Township (Section 35) east of Waukee, where he farmed and they raised four children. The couple moved to town to enhance Clark's business interests in Waukee. He owned the flour mill and, later, the lumberyard. They lived in the white house that still stands a block north of the current co-op. Initially, the mill was across the street from the house, but it later was moved farther north. (Courtesy of Marcia Blake Mills.)

Waukee business owner Spencer Smith married Martha Schaeffer, sister to his brother Clark's wife, Mary. Spencer and Martha owned the Waukee Hotel, livery stable, and opera house. He built the city hall and a skating rink. Spencer was also a grain trader. Pictured are, from left to right, Harry, Laura, Spencer, and Martha Smith. (Courtesy of Marcia Blake Mills.)

The Waukee Hotel, seen is in the back right corner, was established in 1901 by Spencer Smith on the south side of the Triangle. The hotel was built with three stories; as of today, it only has two stories. Margaret A. Stone revitalized the exterior of this historic building in 2004–2005 with financial help from the Revitalization Assistance for Community Improvement grant program and the City of Waukee. (Courtesy of Paul Huscher.)

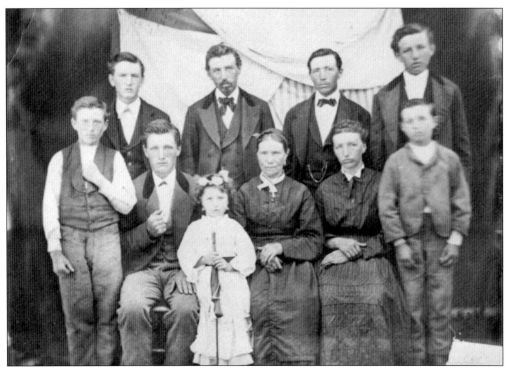

Margaret (Falen) Forret was born in Luxembourg, France, on August 24, 1822. She was married to Nicholas Forret and birthed 11 children; two died in infancy. In March 1863, the family immigrated to America, settling on a farm homestead in Dallas County. Margaret, known as "Grandma Forret," and Nicholas sought the American Dream; however, Nicholas died in 1869, leaving Grandma and sons to manage the farm. Grandma was undaunted; she clothed her nine children with knitted stockings and clothes sewn from cloth made with wool gathered on the farm. Pictured above are, from left to right, (first row) Edward, John, Elizabeth, Grandma, Magdalena, and Champ; (second row) Jacob, Nick, Matt, and Anthony. On August 24, 1922, five generations celebrated Grandma Forret's 100th birthday on the T.P. Cushing farm near Waukee, pictured below. Margaret died on February 11, 1925, at age 102. (Both, courtesy of Dena Angaran Forret.)

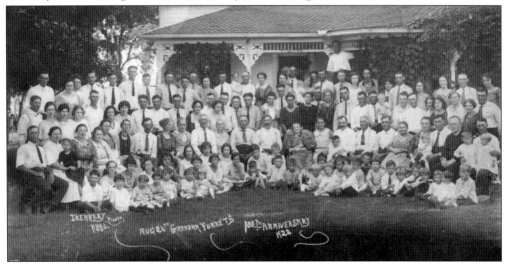

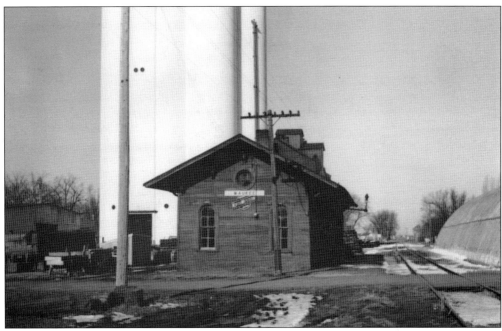

The Des Moines Valley Railroad came to Waukee in 1869, bringing growth with it. The line was leased by the Rock Island Line in 1904 and was eventually purchased by the Minneapolis & St. Louis Railroad. Pictured above is the Minneapolis & St. Louis Depot. In 1878, a narrow-gauge track, the Des Moines Adel & Western Railroad, ran east and west on the north side of what became Hickman. The depot pictured below was built in 1880 north of Hickman and became known as the Milwaukee Depot. Beside the depot is John Kudej, the station agent at this time. On the handcar are, from left to right, section foreman Ted Finnane, Ed Huston, Earl Hoeye, and Bill Finnane. The *Dallas County News* reported the fare from Waukee to Adel as 28¢ in 1880. (Both, courtesy of Paul Huscher.)

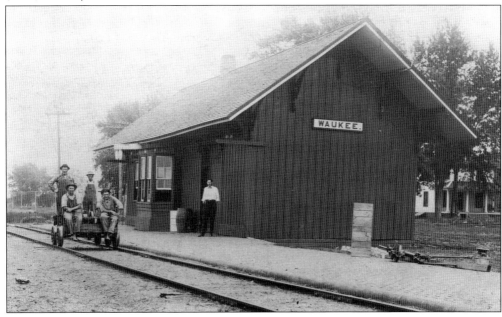

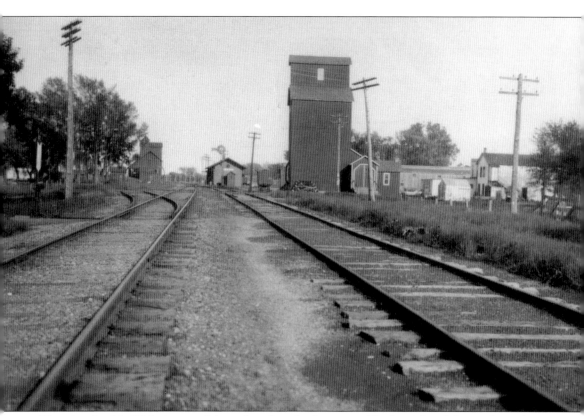

The view in this 1914 picture of the railroad tracks faces east. To the right of the tracks is the elevator of the Farmers Elevator Company, built in 1909. H.I. "Irv" Shoeman was the first manager. The Farmers Elevator Company also operated Jess Copeland's old grain elevator, which was east of the Minneapolis & St. Louis Railroad Depot. (Courtesy of Paul Huscher.)

The Waukee Presbyterian Church, built in 1870, served for three years as the first schoolhouse, with a student population of three. The first school building, pictured at right, was erected in 1874 or 1875 and consisted of two schoolrooms and two recitation rooms. A principal, a teacher, and a four-member school board facilitated the learning of 85 pupils in primary education. Pictured in the doorway of the school is Hattie Blackman Brumfield, one of the first pupils. By the turn of the century, the school included nine grades. Pictured below is this same building as it stands today. (Right, courtesy of John Snyder; below, courtesy of Terry Snyder.)

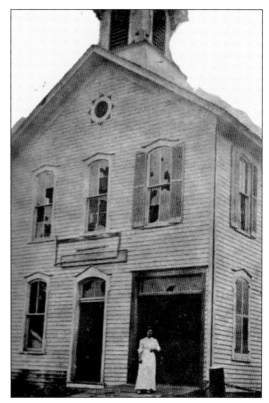

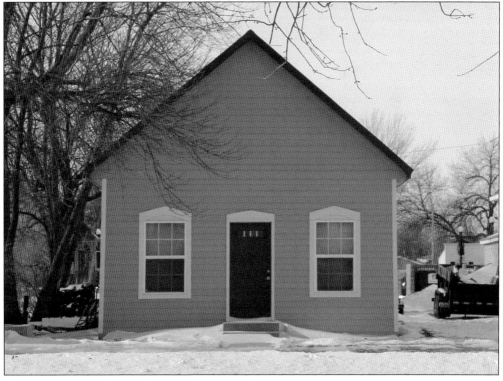

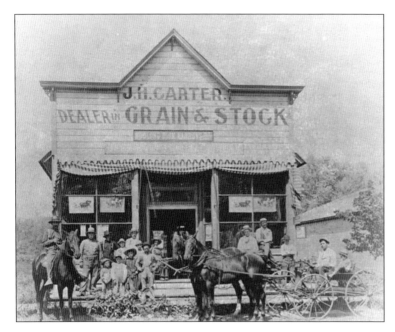

One of the first retail businesses in Waukee was J.H. Carter Grain & Stock, established around 1890. John H. Carter, a farmer who emigrated from Canada in 1876, initiated the business that was located on the north side of the Triangle. The business sold coal and grain stock. This building burned in 1901 and was replaced by the structure below. (Courtesy of Paul Huscher.)

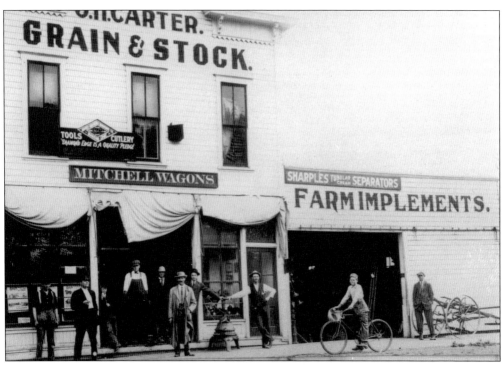

John H. Carter's business prospered and grew with Waukee. In the early 1900s, a farm implement building was added to the east side of the business. By the 1920s, two sons, John W. and Burt, joined the business; it was renamed J.H. Carter & Sons. (Courtesy of Paul Huscher.)

J.H. Carter's son John W. is pictured here. The Carter sons continued the business until the 1950s, making it one of the longest-operating enterprises in Waukee. People said that John W. managed the inventory while his brother Burt kept the books. If a customer requested an item that was not immediately available, John W. would drive into Des Moines to pick it up. The second story was used as a meeting place; some people remember Thanksgiving dinners being served there. (Courtesy of Paul Huscher.)

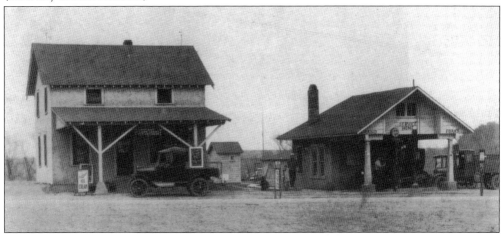

Grand Forks was two miles south of Waukee on the corner of what are now Ashworth Drive and L.A. Grant Parkway. Ashworth was also known as White Pole Road because of the white utility poles that lined the road. Larry Snyder ran the service station, and his sons would pump the gas from one of the hand-cranked pumps. They had a garage equipped to work on Ford Model As and Model Ts. (Courtesy of Larry Snyder.)

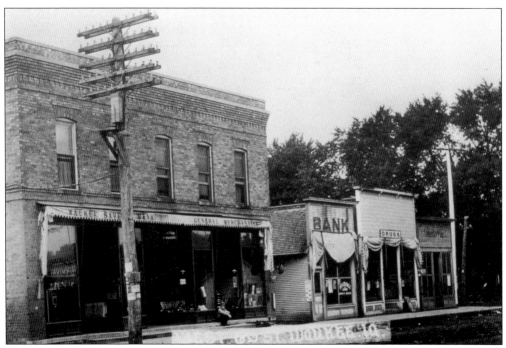

By 1890, the town had grown enough to need banking facilities. Pictured on the left is the first bank, Waukee Saving Bank; it was located on the west side of the Triangle in what was known as the Brumfield Building. The small frame building in the center was erected in 1901 to house the Bank of Waukee. Fire destroyed the structures in 1941. (Courtesy of Larry Phillips.)

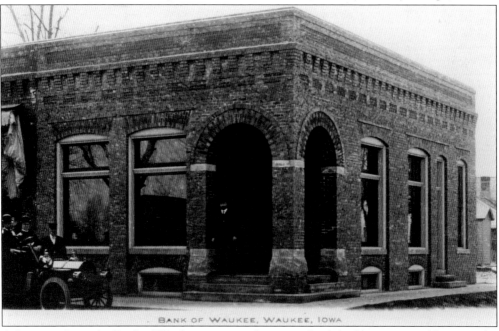

A few years later, the Bank of Waukee was moved to a new brick building, pictured here, on the corner of Sixth and Walnut Streets. Later, it became Brenton State Bank. Currently, the building houses a local pub. (Courtesy of Larry Phillips.)

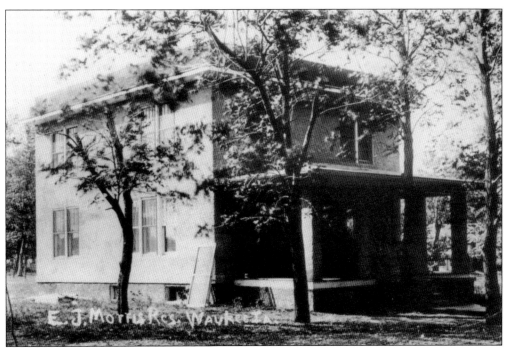

One of the original houses in Waukee, this property was owned by E.J. Morris and was located on Sixth Street near the south end of town. (Courtesy of Paul Huscher.)

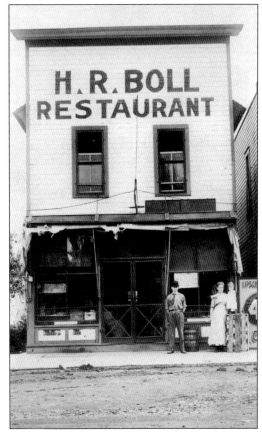

Pictured here is the City Restaurant, which was located on the north side of the Triangle and was owned by Harvey Boll. In front of the restaurant are, from left to right, Harvey, Mary, and Marie Boll. Although the date of establishment is uncertain, records indicate the business was doing well in 1895, advertising "the largest and best line of cigars and tobaccos . . . and all temperate drinks." (Courtesy of Marcia Blake Mills.)

In 1864, Isaac Newton Aldrich left Ohio at age 19, driving a team of condemned Army mules westward. Upon reaching eastern Dallas County, Isaac bought 80 acres, broke sod, and eventually transformed it into a 600-acre farm. He and his wife, Lucy Ellis, raised eight children: Charles, Delbert, Pearly, Stewart, Tom, George, Warren, and Bessie, many of whom have descendants still in the community. (Courtesy of Mary Thomas Scheve.)

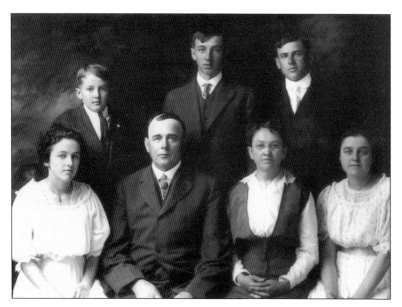

Isaac Aldrich's eldest son, Charles Christopher, born in 1868, operated a farm in Walnut Township along with his wife, Louise Belle Robertson, and their five children—Walter LeRoy, Grace (Aldrich) Felt, Charles Floyd, Estella (Aldrich) Elson, and George Newton. (Courtesy of Mary Thomas Scheve.)

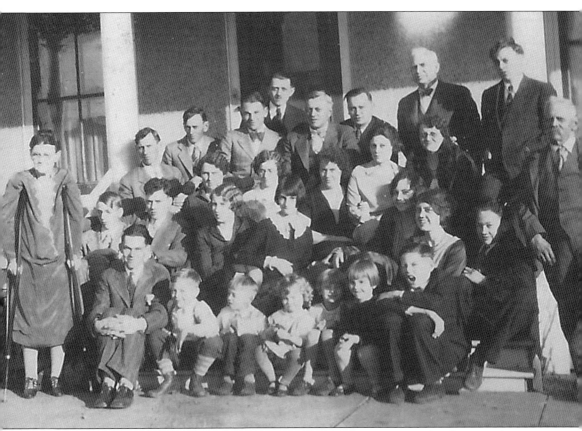

Charlotte and John S. Shoeman are pictured with their five sons, two daughters, and many grandchildren in front of their home in 1926. The Century Home (a 100-year-old house) is still standing. John C. Shoeman, who was born and raised in the home, still lives there with his wife of 59 years, Barbara. They raised four children—Debra, John, Teresa, and Robert. The land is farmed by son-in-law and grandson Tim and Chase Broderick. (Courtesy of Teresa Shoeman Broderick.)

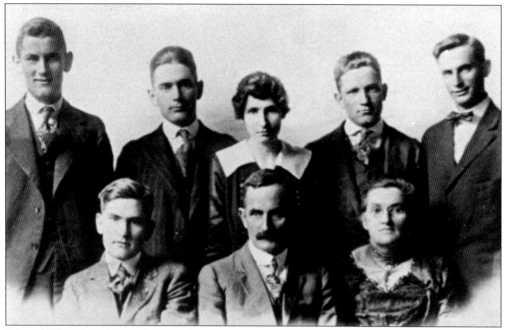

Edward W. and Catherine Broderick migrated to Dallas County in 1872 from Illinois with their young children. The family acquired a land grant and purchased 40 acres from W.H. Rollins. Edward died that same year. When son Ed was 14, his mother became very ill and required surgery. The surgeon came from Des Moines to perform the operation in the home of Betsey Snow. Recovery was not good, and Catherine died in 1886. Ed married Catherine Moran (pictured) of Adel in 1891 and acquired land that is still farmed by his nephew Phil, great-nephew Tim, and great-great-nephew Chase. In the photograph are, from left to right, (first row) Bill, Edward, and Catherine; (second row) Charles, Dan, Anna, Leo, and Ed. Mary, the youngest child, died at birth. (Courtesy of Teresa Shoeman Broderick.)

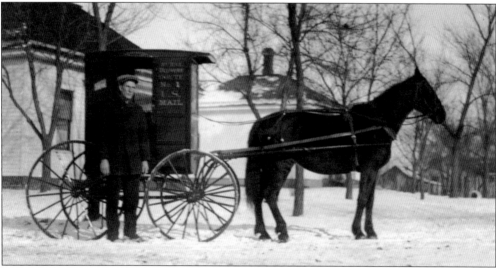

The first post office in Waukee had been established in 1869 and was located in the drugstore owned by the postmaster. This unidentified mail carrier used a horse and buggy to reach the rural areas of Waukee. (Courtesy of Marcia Blake Mills.)

Three

COAL MINES AND COMMUNITY

The Shuler Coal Mine offered for many Waukee immigrants from Italy and central European countries a job. It was a diverse working group. The Shuler Coal Mine operated from 1921 until May 1949. It had an open mine that went down 387 feet underground. Coal was mined in rooms that followed veins as far as three miles in all directions.

The Shuler Mine leased land from the farmers in the vicinity of the mine, on which it built a community of homes for the workers. There were three such communities, known as the North Camp, the Middle Camp, and the South Camp. Also, the Shuler family built a general store and tavern for use by the mining community. The general store provided food products, cooking utensils, and a few toys for the children. The tavern provided miners a location to play cards or bocce ball, dance, and gather socially. Many wedding parties, Catholic First Communions, and socials were held in the tavern.

One of the social highlights was the arrival of freight cars that brought grapes from California. These grapes were used by immigrant miners for making wine.

Supplementing the general store was the home delivery of ice for the iceboxes. Italian foods, such as sausage, cheese, and breads, were also delivered from an Italian store in Ankeny, Iowa. The Omar and Watkins deliverymen brought their products to the homes.

The Shuler Coal Mine was the largest in the state. This mine provided coal to heat the universities, industries, government buildings, and homes of Iowa. Some of the coal was sent out of state to provide fuel to power electrical service.

Working in the mine required hard physical labor, and there were many dangers that the men had to be aware of. There were several injures at Shuler Mine during the years of operation. Some men were killed; others lost eyes or had limbs broken during cave-ins

There are many good memories of growing up in the coal mine communities, which can be seen in the pictures that follow.

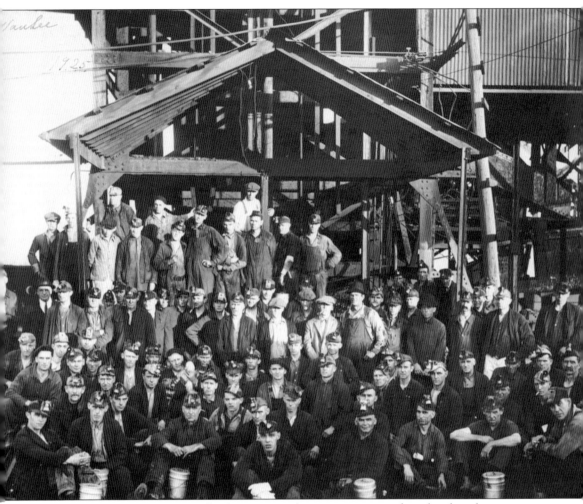

As early as 1883, a group of Waukee businessmen began to meet regarding the idea of prospecting for coal in the area. This remained only a dream until 1919, when a man named Harris came to the community to seriously explore the idea of establishing a coal mine. By 1920, Harris dug a 417-foot-deep mine shaft and erected the proper infrastructure to facilitate the first coal mine in the Waukee area. It was a very modern coal mine for the time, having electric lights in the lower main entries and a good ventilation system. The Harris Mine was located approximately three-quarters of a mile west and slightly south of the Shuler Mine shaft. The mining operation continued from 1920 until 1927. (Courtesy of the Waukee Public Library.)

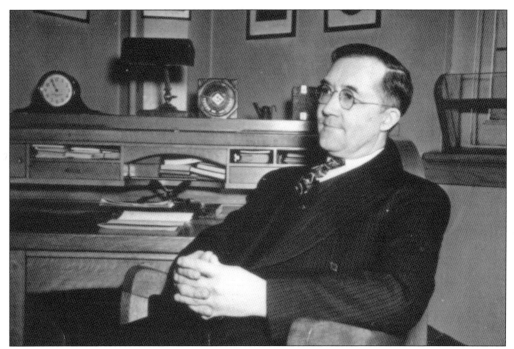

The last superintendent of the Shuler Mine was J.W. "Joe" Johnson, pictured here. He received his civil engineering degree at Iowa State University, paid for by John Shuler, and in turn, Joe worked for Shuler until the mine closed on May 27, 1949. (Courtesy of Jeff Johnson.)

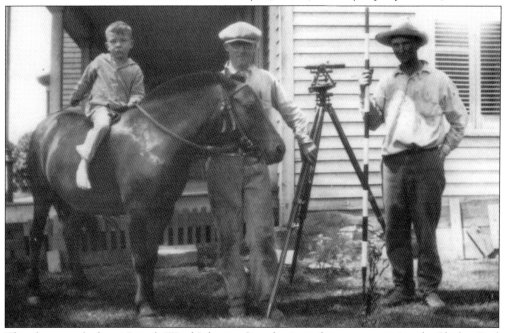

The photograph shows Joseph Ward Johnson Sr., who is working on surveying the Shuler Coal Mine while his young son Joseph Ward Jr. sits on the horse. An unidentified man is holding a surveyor's pole. Surveyors' responsibilities included location of mine boundaries and drilling holes to see where the coal shafts should be. (Courtesy of Jeff Johnson.)

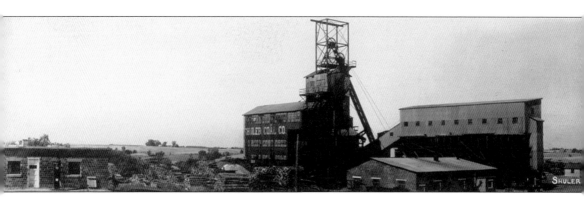

There were coal mines all over the state of Iowa in the late 1800s. Speculators first surveyed Waukee in 1883. The Harris Mine opened on September 20, 1920, just two and a half miles northeast of Hickman Road in Waukee. The Shuler Mine, owned and operated by the Shuler

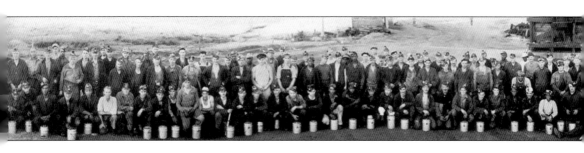

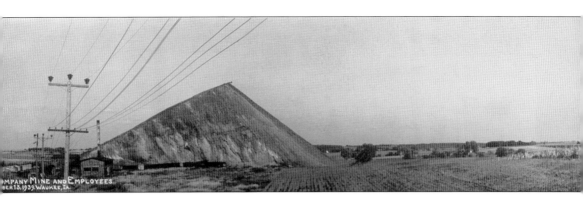

MPANY MINE AND EMPLOYEES
OER 13. 1935. WAUKEE, IA.

Coal Company, operated in 1921. It was the largest producer of coal in Iowa, and it had the deepest mine shaft—387 feet. It was located one mile east of Harris and closed on May 27, 1949. It employed up to 500 men and used 32 mules. (Both, courtesy of Pat Ramsey.)

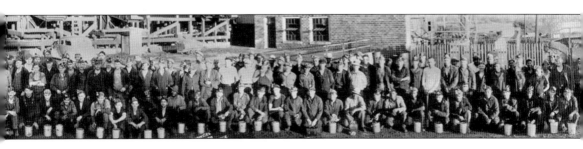

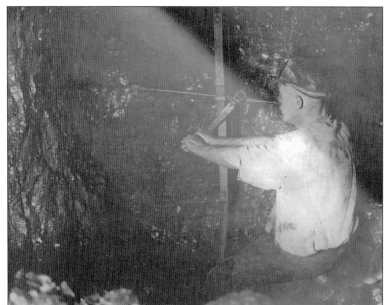

An unidentified miner is putting up timber to prevent cave-ins. Timbers were cut and put into place with hand tools. The miner is wearing a carbide lamp in this picture; these were essential in working down in the caves. (Courtesy of Madrid Historic Museum.)

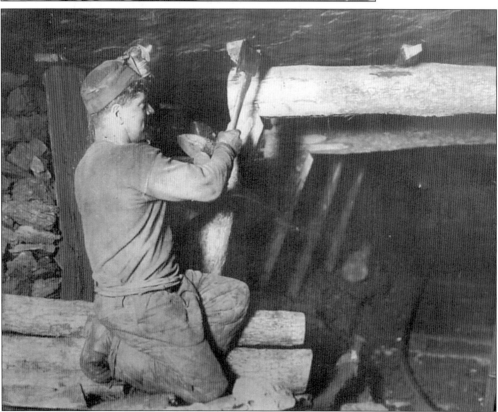

An unidentified miner is drilling into the coal vein to set a dynamite charge to blast loose the coal to be loaded into the coal cars. This was done in the evenings, so the workers would not be in the area. The dynamite work usually was completed by only one employee. (Courtesy of Madrid Historic Museum.)

Every evening, the coal was blasted from the coal vein. In the morning, it was broken into sizes that could be loaded into the coal cars and brought to the surface. This unidentified miner is using a pickax in the small confined area. (Courtesy of Madrid Historic Museum.)

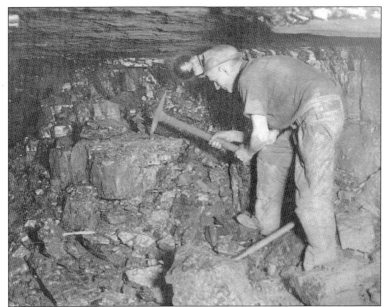

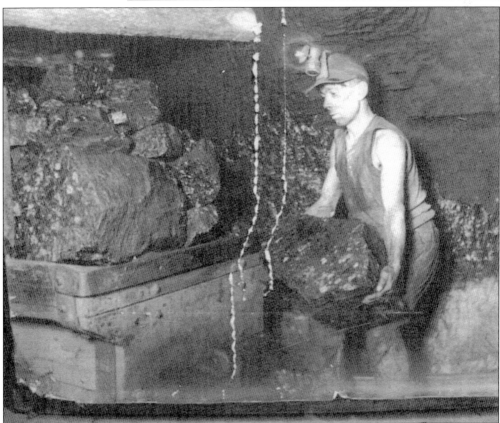

After the coal was broken into 20- to 50-pound pieces and loaded into the coal cars, mules would pull the cars to the elevator to be taken to the surface. This unidentified miner is lifting the pieces of coal by hand. (Courtesy of Madrid Historic Museum.)

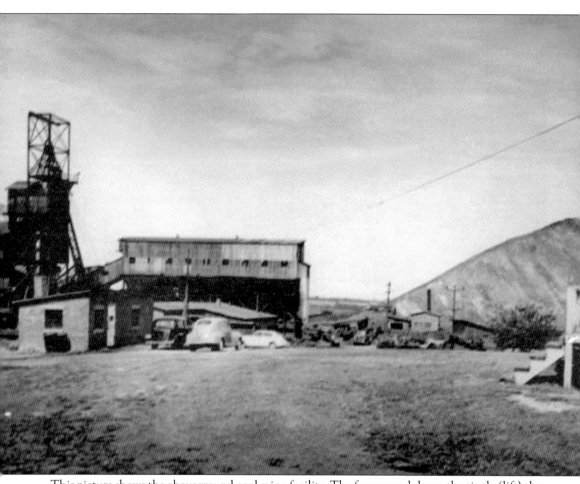

This picture shows the aboveground coal mine facility. The foreground shows the tipple (lift) that raises and lowers everything that enters and leaves the deep mine below. This building is also where the coal was distributed to either railcars (on left side of the tipple) or to the coal trucks (to the right of the tipple). The shale pile was one of the largest in Iowa and other states. This pile was derived from the spoils of the mined coal (rock/slate or coal mixed with rock/slate). Workers would pick these spoils from the conveyor belts before the product reached a storage area. The spoils were carted by a small railway dump car up to the steep "gob pile" grade and released onto the mammoth pile. The pile was constantly in a state of scattered burning pockets that could be seen for miles. (Courtesy of the Andreini family.)

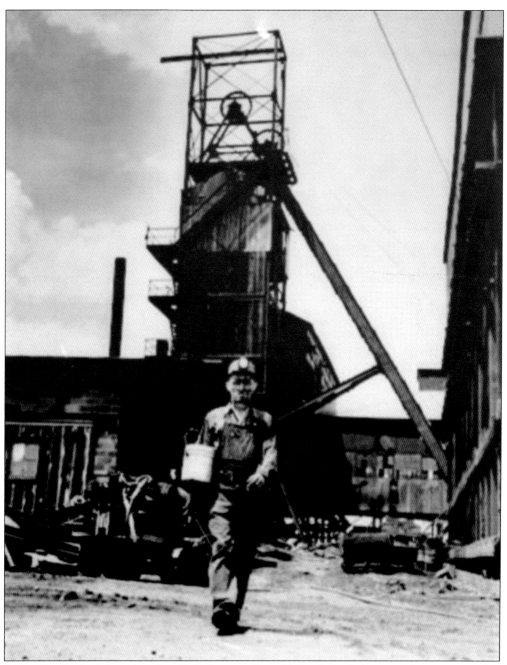

When the Shuler Mine closed in 1949, foreman Donald Cruikshank (pictured here, carrying his lunch pail) was the last man out. He lived in Waukee with wife, Alberta, daughter, Karen, and son, Donald Jr. Donald had been a miner since 1918, working in the old Hocking Coal Company mine Nos. 3 and 5, the old Riserville Mine, Maple No. 1, Happy Hollow, and Economy before coming to the Shuler Mine. He worked all his adult life in the coal mining industry. His father, Daniel Cruikshank, died in the Shuler Mine in 1937 at the age of 69. It is estimated that about 15 people lost their lives in the mine, and many others suffered severe injuries. A siren alerted workers and residents of accidents in the mine. (Courtesy of the Cruikshank family.)

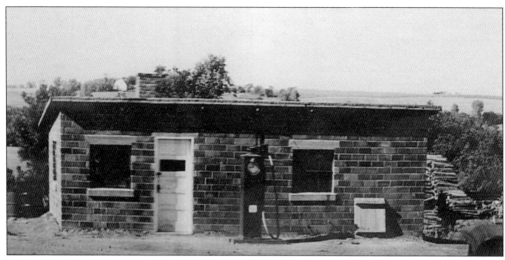

This picture shows the gas station used for fuel and repair of trucks and cars associated with Shuler Coal Mine. It is also a small storage area for related vehicle repair parts. It was open 24 hours a day. (Courtesy of the Andreini family.)

Miners would gather inside the Shuler Mine Camp tavern after work to have a drink, play cards, and socialize. In the photograph, one can see an assortment of goods that the tavern sold. Among them are pipes, tobacco, chewing gum, chips, cigars, popcorn, and combs. Children would visit the tavern to buy soda for only 5¢. Pictured are, from left to right, Lucy, Dima, Feruccio, and Diana Lami. (Courtesy of the Ori family.)

Waukee military personnel celebrate their leave at the mining tavern in 1941. Times at home during the war were treasured, as was the opportunity to catch up with family and friends. It was a time when they could be carefree before heading back to their respective duties in the US armed forces. From left to right are Harry Lux, Telio Ori, Bernard Olson, and Hiram Ori. (Courtesy of the Ori family.)

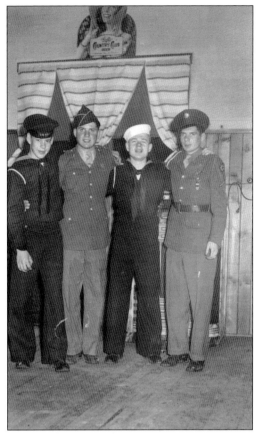

Shuler Mine Camp accordion players are, from left to right, Louie Kruzick, Irma Ceretti, Albina Sepich, and Louie Ceretti. Accordion music was very popular in mining camps. A variety of polkas and waltzes were played. This picture was taken in Des Moines, Iowa, at what appears to be a beauty pageant. (Courtesy of the Andreini family.)

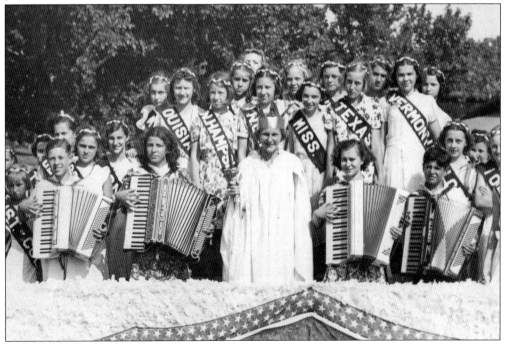

Eatilo Angaran was one of the many who played baseball on town teams in the surrounding communities. He played on the Shuler Coal Camp team as a pitcher, later advancing to the minor-league ranks. He pitched many games against the greats of his time, including Bob Feller, Hal Manders, and many others. (Courtesy of the Andreini and Angaran families.)

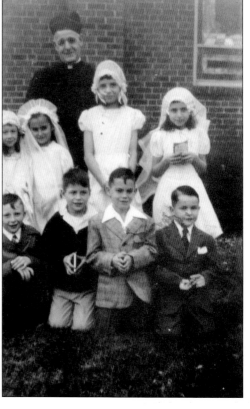

A 1944 First Communion celebration at St. Boniface Catholic Church was the occasion for this photograph. Father Aldera is pictured with, from left to right, (first row) George Robinson, Richard Ori, Denny McKinney, and Tom Lauterbach; (second row) Diana Lami, Lucy Lami, Agnes Ori, and Olga Ori. This event was a great time for celebration and socializing in the mine community. (Courtesy of the Ori family.)

The 1915 graduating Shuler Mine School citizenship class successfully passed the government naturalization tests to become American citizens. This education was provided by the Shuler Mine School. In the photograph are, from left to right, (first row) Pelliprino Stefani, Primo Rossi, Ida Miller (instructor), Stanoliv Polich, and Feruccio Lami; (second row) Fulvio Barbieri, Edward Sepich, Dominic Lamberti, Domenica Ferarri, Angelo Stefani, Desiderio Andreini, Joe Perkovich, and Hilary DiPagliai. (Courtesy of the Andreini family.)

The children of the mining camp would go to Bible camps in the summer. Pictured at right are the mining camp children in 1944 at the Christian church in Waukee. Activities were a time for cementing community friendships and served to provide moral guidance in young people's lives. All community children were welcome, with no attention given to their nationality or church affiliation. (Courtesy of the Dluhos family.)

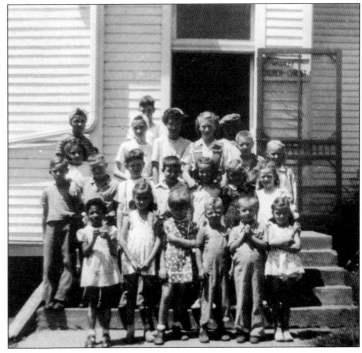

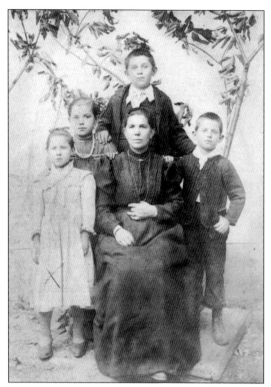

Pictured at left in 1904 are, from left to right, (front row) Casimira, the mother of Hiram Ori, and her mother, Angela Colombi; (second row) siblings Gertrude, Silvio, and Giulio. Casimira immigrated to the United States from Italy in 1913, married Ernesto Ori, and gave birth to 13 children. Ernesto worked for the Schuler Coal Mine in rural Waukee. The Ori family lived in the coal camp area until Casimira's death in 1978. They were the largest family in the Italian community. Below are the Ori children at the last reunion that brought all the family together. From left to right are (first row) Yolanda, Mafalda, Agnes, and Olga; (second row) Gildo, Arthur, Alfred, and Richard; (third row) Hiram, Telio "Ted," and Angelo. (Both, courtesy of the Ori family.)

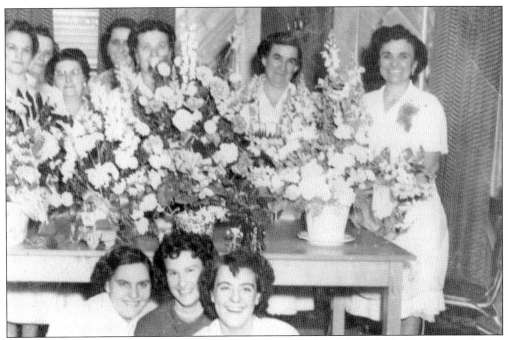

The picture above is of the grand opening of the new building for Alice's Spaghettiland. The crew of women includes, from left to right, (first row) Bernadine Rossi, Mary Grace Fiori, and Francis Nizzi; (second row) Francis Andreini, Jo Martin, Mable Clarkson, Armalinda Rossi, Maria Negrinotti, Anita Fiori (Alice's sister), and Alice Nizzi. The waitresses were required to wear "white starched uniforms." Alice's doors were closed in 2004. Years later, approximately 500 people from surrounding areas came to the Waukee Area Historical Society fundraiser dinner featuring Alice's spaghetti and Italian salad in the spring of 2014. The picture below shows Rosie's Italian Restaurant located near the Shuler Coal Mine. This restaurant served authentic Italian food and was popular with people from Des Moines, Waukee, and surrounding towns. In the kitchen are, from left to right, Albina Sepich, a Mrs. Tollari, and Rosie Vanni. (Above, courtesy of the Andreini family; below, courtesy of Rick Huscher.)

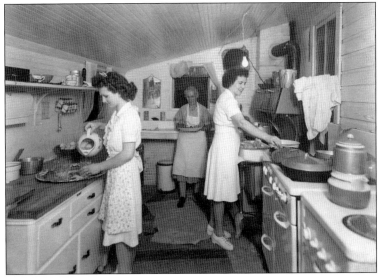

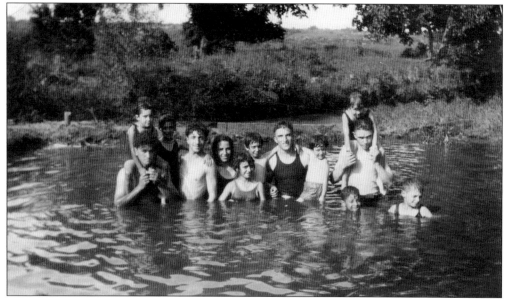

In the summer, swimming in the gravel pits was a common recreation for many Shuler Camp families. In addition to water activities, the family picnics were usually a source of fun for all. Siblings were known to take care of each other while the adults enjoyed time together. (Courtesy of the Andreini family.)

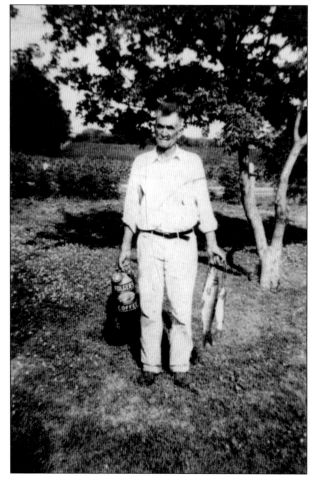

At the Shuler Mine Camp, men hunted and fished to supplement meals. They hunted squirrels, rabbits, and pheasants, only shooting or catching what they planned on eating for the current family meal. They also raised chickens for meat. Pictured is Bartolo Nizzi coming home with his day's catch from the Raccoon River. (Courtesy of the Nizzi family.)

Terzo Fiori (left) and Pete Nizzi are pictured tasting their homemade wine. The grapes were imported from California by two railroad boxcars to make yearly supplies of red wine. The grapes were distributed to the mining families and families in towns nearby. Grape distribution was a day of celebrating for children. Treats, such as figs and yams, arrived with the grapes and were thrown from the boxcars, much as in parades today. (Courtesy of the Nizzi family.)

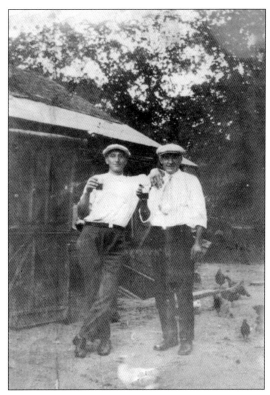

Pete Andreini is kneeling by a garden at the Shuler Mine Camp in front of a toolshed that was later converted into an automobile repair shop. Gardening was essential to many mining camp families for overall food supply. Some of the vegetables and fruits grown at the camp were potatoes, tomatoes, onions, beans, and strawberries. (Courtesy of the Andreini family.)

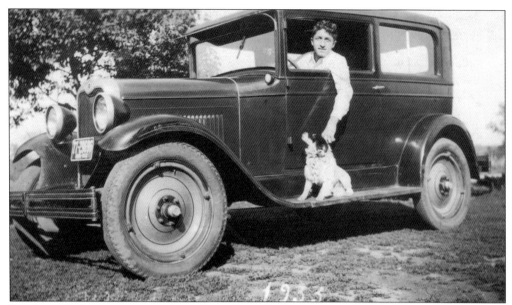

Desiderio Andreini is shown with his dog, who enjoyed riding on Andreini's early-model Chevrolet running board. Before turning a corner, Desiderio would warn the dog of the upcoming turn by making a slight swerve with the car; the dog would immediately lie down, stretched out between the hood and left front fender. (Courtesy of the Andreini family.)

The homes in the coal camp had no frills and no carpet, just wooden floors. There was no indoor plumbing or refrigeration. Water that was obtained from the neighborhood well was heated on a kerosene stove for cleaning, bathing, and other uses. In cold weather, the big coal stoves provided the heat for the uninsulated homes and would typically burn one to one and half tons of coal per year. (Courtesy of Mary Grace Fiori Ladurini.)

The elaborate weddings among the Italian mining families will be long remembered by their descendants. They generally were announced a year in advance so that a carload of grapes could be purchased and other arrangements completed. Traditional Italian weddings have a dessert table with a large cake made of Italian cookies. A cookie dance is started by the bride and groom, much like a line dance is today. When the dance is over, everyone takes a cookie. The wedding pictured here was particularly elaborate, but even for less prosperous families, such events usually included a big breakfast and supper hosted by the bride or groom's family. Rugs in the bride or groom's home were rolled up from the floor in the living room, and often a band would furnish the music for an evening of dancing and celebrating. The nuptial celebrations would go on for days, with coal production dropping to a rather low rate. (Courtesy of the Andreini family.)

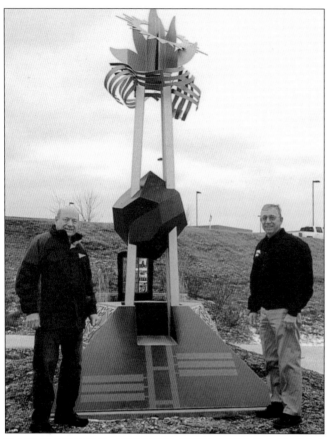

Pictured at left is the Shuler Mine art piece is known as the *Black Diamond*, designed by Rebecca Ekstrand and Thomas Rosborough. It is dedicated to the remembrance of the coal miners who worked in the mine and the people who lived in the coal mine camps. The mine represents an important industry, providing a prime source of energy at the time. Shuler Mine was instrumental in the development of the surrounding communities and had a huge economic impact on this area. The mine was one of the deepest and longest-lasting coal mines in the country, commencing in 1921 and lasting until 1949. Pictured below are Richard G. Ori (left) and Bruno Andreini (right), and in the center is the Shuler Coal Mine Memorial marker at the Waukee Shuler Elementary School. (Both, courtesy of the Ori family.)

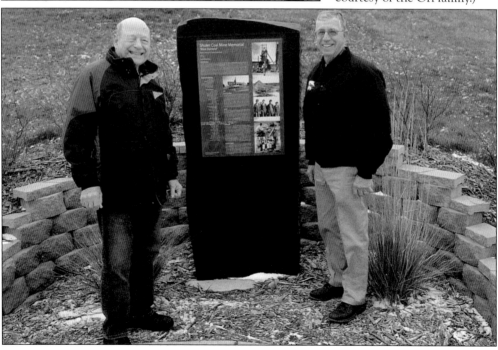

Four

EXPANSION OF EDUCATION

The Presbyterian church built in 1870 became this community's first school, serving that function for a total of three years. Around 1874, the first schoolhouse was erected, a two-story four-room building. Average attendance was 85 pupils. The school curriculum consisted of nine grades.

In 1901, a larger, brick, four-room schoolhouse was built to handle the growth in Waukee's population. The school was divided into four sections—primary, intermediate, grammar and high school (which consisted of two grades).

On July 19, 1917, a petition was signed to form the Waukee Consolidated School District. Walnut Center, Pleasant View, Floral Valley, and Waukee Independent School, all in Walnut Township, merged into this district, including portions of Boone and Van Meter Townships. Prior to this time, there were five country schools that dotted the township. A superintendent; horse-drawn–buggy transportation to school; a four-year, fully accredited high school curriculum; and other responsibilities became part of the new school district.

In January 1918, a large three-story brick structure, now named the Vince Meyer Learning Center, opened. Waukee Community School District was established and remained a small, rural school into the 1980s. In January 1926, because of overcrowding in the town school, the Shuler Mining School was built to teach children living in the Shuler Mine Camp. It consisted of grades one through six. The current Shuler Elementary School was named in memory of the coal industry that helped shape the community.

In the 1990s, the population began to expand west of Des Moines, resulting in 20 years of continuous growth for the Waukee School District, which became the fastest-growing school district in Iowa. Today, Waukee has more than 900 staff members serving more than 8,000 students, from preschool through 12th grade. The students served are from Clive, Urbandale, Waukee, and West Des Moines, and also include open-enrollment students within 55 square miles of the district boundaries. There are 12 school buildings, including 7 elementary schools, 2 middle schools, a ninth grade, and a high school. Plans are underway for a new high school around 2018–2020.

In 1901, a new brick school was built to handle the growing number of students. The large four-room brick building was divided into four sections—primary, intermediate, grammar, and high school. It was located on the northeast corner of Locust Street and Fourth Street. (Courtesy of Paul Huscher.)

This 1899 photograph of Waukee High School students includes Milvern Boll and cousin Ralph Boll. Among the other students are Carrie Bass, Maude Dowler, Earle Elliott, James Kenyon, Catherine Carter, Myrtle Cowger, Harry Jones, George Jones, Charles Nash, Bert Carter, and Ed Youngerman. In 1899, the school consisted of nine grades. Additional grades were begun in 1901, 1903, and 1906 to make 12 grades. (Courtesy of Marcia Blake Mills.)

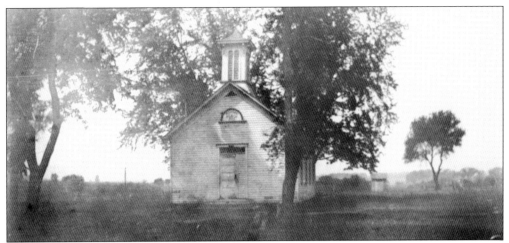

Rural one-room schoolhouses dotted the countryside. Each rural district had a schoolhouse in the center of its four-square-mile area, which amounted to a schoolhouse every two miles. There were eight in each township. These one-room, one-teacher schools included all eight grades. Upon completing eighth grade and county examinations, students qualified for high school. This 1905 photograph is of the Pleasant Plain Country School located in Section 13 of Walnut Township. (Courtesy of Marcia Blake Mills.)

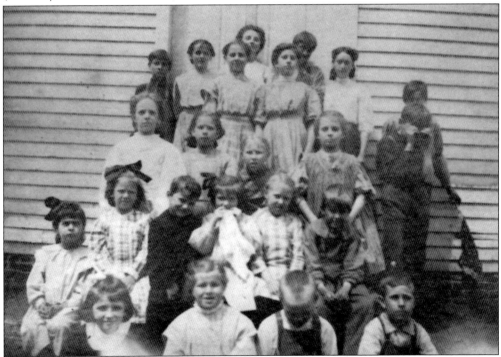

This 1906 photograph shows Pleasant Plain students with teacher Mrs. Patch. Students pictured are George Campbell, Grace Aldrich, Floyd Aldrich, DeLoise Aldrich, Levi Jordan, Charley Jordan, Grace Kent, Bessie Anderson, George Hoskins, Arthur Houghtaling, Bertha Houghtaling, Knounie Houghtaling, Mary Houghtaling, Roy Aldrich, Stella Aldrich, Warner Aldrich, Hazel Jordan, Oakel Jordan, Anna Young, Otto Anderson, Frank Anderson, and Delbert Hoskins. (Courtesy of Marcia Blake Mills.)

In 1908, Pleasant Plain families included the Anderson, Aldrich, Campbell, Hoskins, Houghtaling, Jordan, Kent, Jordan, and Young families. Playground equipment, such as swings, chin-up bars, and slides did not become popular until after 1900. Outdoor games played by students were limited only by their imaginations. (Courtesy of Marcia Blake Mills.)

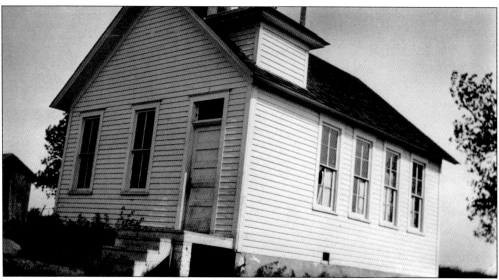

Pleasant View Country School was located in Section 13 of Walnut Township. In 1915, students included Marie Young, Paul Johnson, Everett Dann, Sherman Johnson, Mary Smith, Marion Aldrich, Thelma Marrion, Howard Dann, Burton Bass, Bea Smith, Leo Forret, Margaret Forret, Howard Miller, Frank Smith, Royal Smith, Velma Marrion, Alta Dann, Darline Aldrich, and Mary Forret. Their teacher was Elsie Cook. (Courtesy of Marcia Blake Mills.)

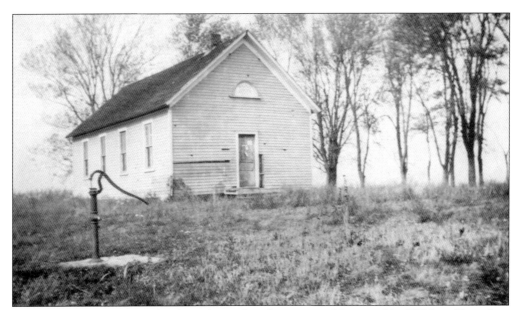

Walnut Center Country School was located in the corner of Section 22 of Walnut Township. Among the families who attended this school was the Bert Blake family. School sites were normally selected in a corner of a section in order to minimize disruption to the neighboring farm. Typically, farmers donated the land, and the land reverted to the original owner when the school was closed. (Courtesy of Marcia Blake Mills.)

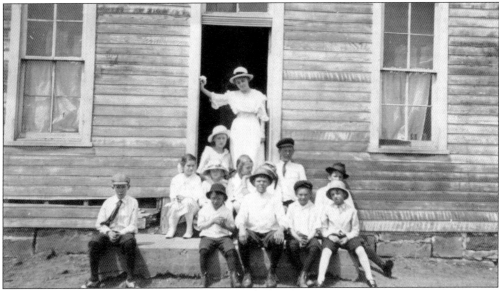

Valley Grove Country School was located in the corner of Section 17 of Walnut Township. Among the families who attended this school was the Mathis Boll family. Country schools were not only the center of learning; they were the center of many activities in the neighborhood. The school was used for box suppers, pie suppers, recitals, singing schools, spelling and ciphering contests, debates, and recreation, as well as church services. They were where the community gathered and socialized. (Courtesy of Marcia Blake Mills.)

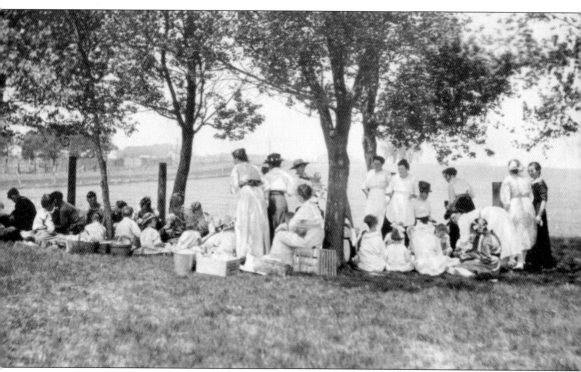

Valley Grove students and their families enjoyed a school picnic. Walnut Township had independent school boards of three or four members for each county school who were responsible only to the county superintendent. The Walnut Township schools were named, rather than numbered (as in other areas of the county). Those in the Waukee area of the township included Walnut Center, Section 22; Valley Grove, Section 17; Pleasant Plain, Section 13; Pleasant View, Section 25; and Floral Valley, Section 20. Sections of Boone and Van Meter Townships were also included in the new Waukee Consolidated School formed in 1917. The schools in those townships were numbered. (Courtesy of Marcia Blake Mills.)

This photograph is from Hazel Forret's miniature scrapbook. These four girls comprised the entire graduating class in 1911. Commencement was held May 25 at the Christian Church. The seniors each wore white eyelet dresses. Pictured are, from left to right, Gertrude Llewellyn, Vera Bernice Nash, Elizabeth Crispin, and Hazel Marie Jordan. Hazel was a 1906 student at the Pleasant Plain Country School. (Courtesy of Hazel Forret.)

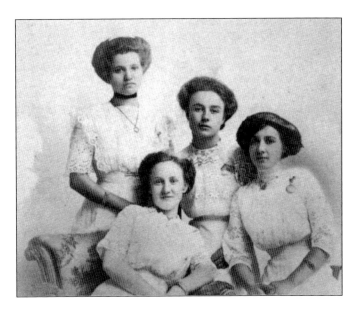

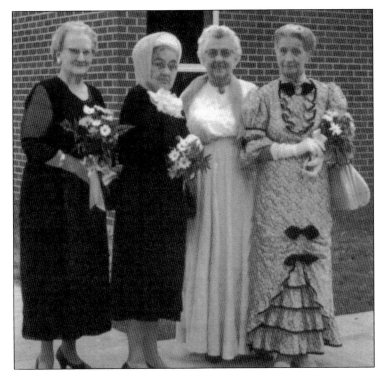

This 1969 photograph, taken at the Waukee centennial celebration, includes the entire graduating class of 1911. The women of the class are, from left to right, Vera Nash Jones, Bessie Crispin Smith, Hazel Jordan Forret, and Gertrude Llewellyn. They had attended school in the four-room brick school building. (Courtesy of Charlotte Swallow.)

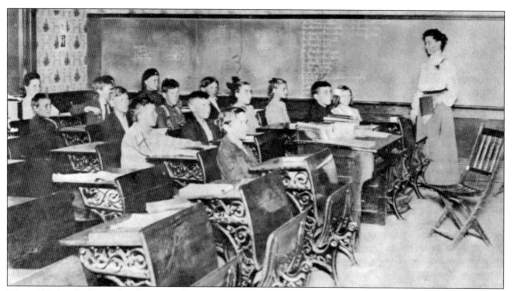

This 1906 eighth-grade photograph includes teacher Mrs. Little. Some of the students identified are Alfred Swallow (first row, boy in front seat), Ray Myers (boy sitting behind Alfred), Jessie Sansbury (third row, girl with hair ribbon), and Sam McWilliams (third row, boy in front seat). (Courtesy of Marcia Blake Mills.)

These Waukee students are gathered in 1915 in front of the high school building. Students graduating that year included Eva Shoeman, Ella Shannon, Stella Aldrich, Lela Foft, Lowell Dougherty, Charles Broderick, Harlan Crispin, and Taylor Cowger. Anna Young was also in the class and this picture, but she finished high school at West High in Des Moines while boarding with her Trostal cousins. Doris Mullins graduated in 1916. (Courtesy of Marcia Blake Mills.)

These 1916–1917 first-and-second-grade students are seated with their teacher at the 1901 schoolhouse. Pictured, from left to right, are (first row) Dan Boone, Ralph Aldrich, unidentified, Ray Snyder, Lillis Butler, Evelyn Fox, and unidentified; (second row) Leonard Henderson, Paul Price, Merle Ehrhart, Marguerite Stump, Robert and Richard Middlekauf, and Lyle Shannon; (third row) Florida Smith, three unidentified children, and James Procise; (fourth row) unidentified, Mildred Myers, and unidentified. (Courtesy of Paul Huscher.)

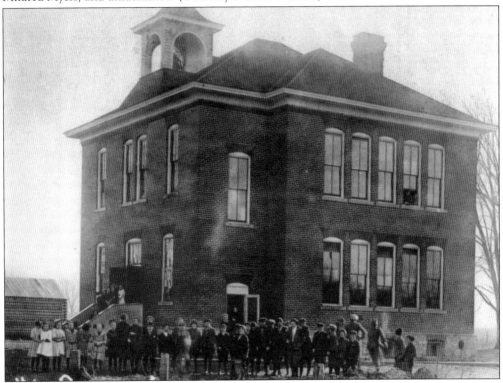

Students pose in front of the 1901 school building. This was a large four-room brick structure that was divided into four sections—primary, intermediate, grammar, and a two-grade high school. During the early 1900s, teacher training was held at the Teacher's Institute in Adel during the summer months. Teachers had to be 18 years of age before receiving a certificate. (Courtesy of Larry Phillips.)

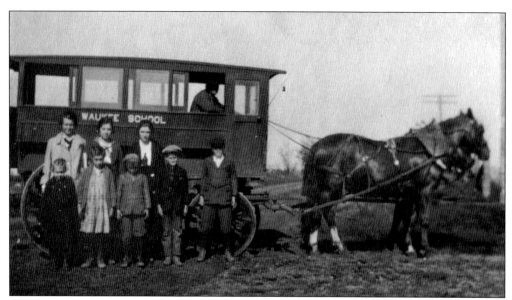

The Waukee School District was created on July 21, 1916. The one-room schoolhouses were replaced with new school laws and school buildings. Additional responsibilities now included providing school bus transportation (horse-drawn wagon), bus drivers, and janitors; creating a four-year, fully accredited high school curriculum for college preparation; and hiring a school superintendent. (Courtesy of Paul Huscher.)

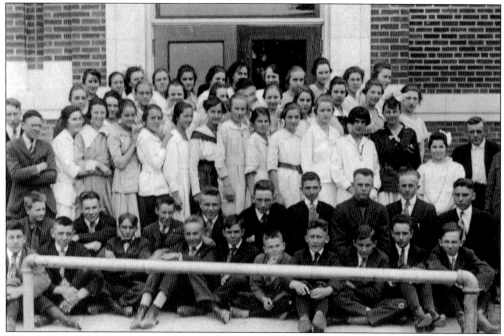

Waukee students gather for a photograph in front of the newly constructed Waukee School, a three-story brick building. The first floor of the school held a multipurpose room that was a gym, lunchroom, and stage for plays. Adjacent was the school kitchen. The second floor had a balcony that overlooked the multipurpose room and provided additional viewing. (Courtesy of Marcia Blake Mills.)

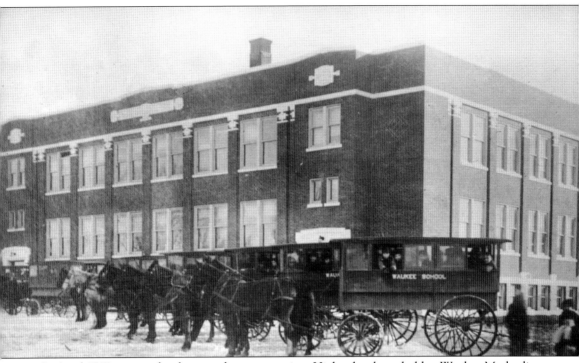

In April 1917, a new school was under construction. High school was held at Waukee Methodist Church until the facility was ready. That fall, new green horse-drawn buses arrived at the church wet and muddy from rain that had lasted all night and morning. The new school opened in January 1918. The old school converted to a teacherage that housed an apartment for the superintendent's family and one for a teacher. (Courtesy of Paul Huscher.)

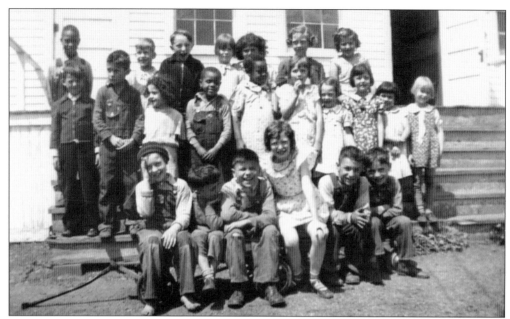

A school opened in the Shuler Mine Camp on January 4, 1926, to educate the mining children. Grades one through six were offered, along with football and basketball. On February 2, 1928, night classes began for immigrant employees who were becoming American citizens, some attending school for the first time. Lena Pedretti Angaran, a camp resident, helped students learn English. The mine closed in 1949. (Courtesy of the Ori family.)

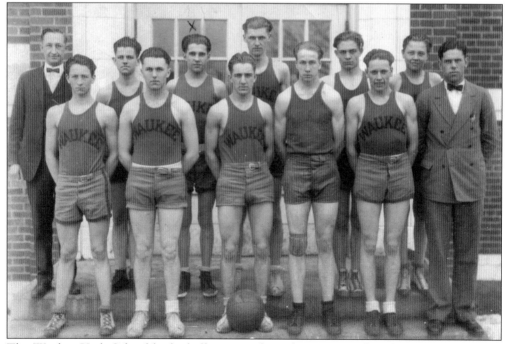

The Waukee High School basketball team and coach appear in this photograph taken on February 22, 1926. Albert Dallam (second row, second student from left) was killed in a sporting incident. (Courtesy of Donna Steffen.)

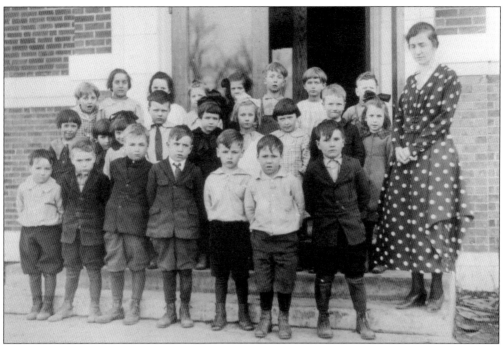

Elementary students pose in front of the new Waukee School. Children's and teacher's attire was more formal than it is today. Memories of games played at recess include marbles, jacks, rope jumping, hopscotch, and red rover, to name a few. School grounds had plenty of large trees that were great to play house under, and they provided piles of leaves to enjoy in the fall. (Courtesy of Paul Huscher.)

Brothers Bruno (left) and Gilbert Andreini wait for the school bus. By this time, the Shuler Mine Camp School was no longer operational. Children from the mining camp were now transported to the school in Waukee. (Courtesy of the Andreini family.)

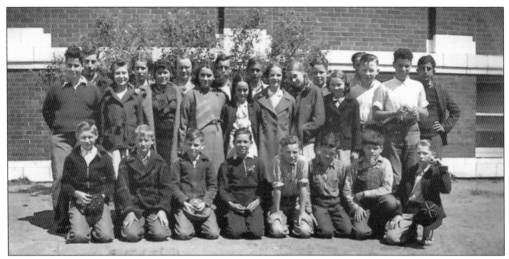

This seventh grade class of Waukee became the graduating class of 1943. The students include Jacqueline Baumeister, Verle Blake, Glen Cadwell, Vernon Downing, Eleanor Eben, Phyllis Eben, Richard Inman, Bernadine Kirk, Pauline Kochheiser, Louie Kruzich, Jean Kuehl, Thelma Linn, Eddie Mitchell, John Morris, Remo Nizzi, Nadine Pearson, Albena Sepich, Darlene Sloan, June Smith, William Timmons, Howard Wilson, Donald York, and Frank Young. (Courtesy of Marcia Blake Mills.)

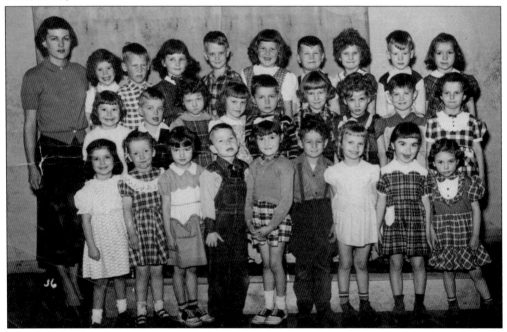

This 1952 kindergarten class became 1964 Waukee High School graduates. Of the 27 students, 15 completed 12 years of school together. Pictured, from left to right, are (first row) Dena Angaran, Doreen Jamison, unidentified, Pat Moran, Suzanne Anderson, unidentified, Nancy Ostring, Minna Muench, and Rosemary Logan; (second row) Cheryl Ross, Carl Raser, three unidentified children, Margie Morris, unidentified, Keith Booth, and Linda Leonard; (third row) Miss Little, Judy Crees, Glenn Grove, Juanita Forret, Warren Peterson, unidentified, Denny Dolmage, Janice Felt, Terry Orr, and unidentified. (Courtesy of Dena Angaran Forret.)

Five

Growth of Waukee

Waukee, like many towns in Iowa, was established and grew as a result of the growth of the railroad west of Des Moines. In June 1869, stations had been identified and christened west of Des Moines. People in Waukee, known initially as Shirley, began to build houses, and within a month, a depot was erected and 320 acres had been laid off in lots for future growth by the founders Maj. Lewis A. Grant and Maj. William Ragan. Letters to the editor were written to encourage people to come to Waukee, and come they did. By the time the city was incorporated in 1878, businesses, organizations, and churches had been established. By the end of the 1800s, Waukee was considered a boomtown with a bright future ahead.

The population of Waukee in 1900 was 292. With the opening of two coal mines in the 1920s, new immigrants moved to the area to work. After the mines closed in 1949, many of these families remained in the area or moved into town, continuing to contribute to Waukee's business and civic community.

Waukee continued to maintain its small-town identity through World War II with a steady growth until 1950, when its population reached 501. The city has seen its largest growth occur since 1950. New housing developments and school expansion started at this time and have continued to keep pace with the growth. The population grew 129 percent between 1960 and 1970, and the city services, including police, fire, and emergency response, were expanded to meet the needs of the increased population. At the city's 100th anniversary in 1969, there was much excitement and pride about the addition of a new park named in honor of the city's centennial.

Since then, businesses have expanded out from the downtown area, including development along Alice's Road east of town and along Hickman Road and University Avenue. The city has continued to grow rapidly, becoming one of the fastest-growing communities in the state; it is also located in one of the fastest-growing counties in the United States.

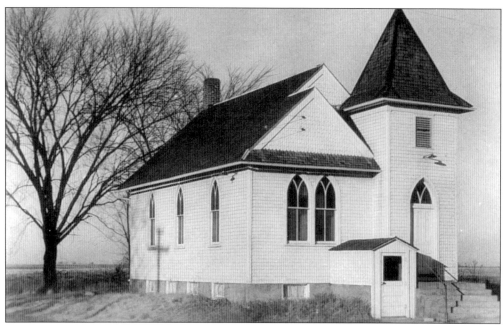

Maple Grove United Methodist Church began in the summer of 1877, in the schoolhouse District No. 2 in Boone Township. When the schoolhouse burned, a new building, called the Brick School, after the Brick family, was erected. Not long after that, a Sunday school was organized there. The Sunday school was closed during the winter because of inclement weather. In March 1900, it was incorporated as the Methodist Episcopal church. A church building was constructed that summer, and it moved from the Brick School. The original building, pictured above, did not have a basement until 1910. The kitchen on the east side of the basement was built in 1949, and the bathroom, in 1970. In 1968, the Methodist churches and the Evangelical United Brethren churches were united to become the United Methodist Church. Pictured below is a more recent picture of Maple Grove United Methodist Church. (Both, courtesy of Maple Grove United Methodist Church.)

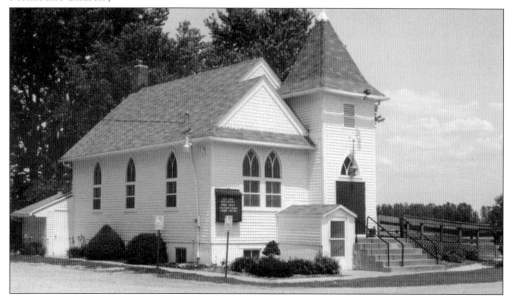

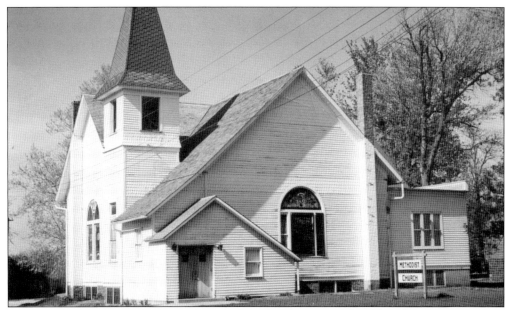

Founded in 1869, the Waukee United Methodist Church is one of the oldest churches in Waukee. The original church members first met in the Des Moines Valley Rail Depot under the name First Methodist Episcopal Church of Waukee. An unfinished church was bought in 1877, and members moved to the new building at Seventh Street and Ashworth Drive in 1878, shortly after the town of Waukee was incorporated. In 1900, a new church was built on the existing foundation, using material from the old church. In 1978, the congregation built a new place to worship on the same site. Highlights of the sanctuary include several large stained-glass windows that were acquired in 1900, 1901, and 1914. These were removed from the original sanctuary and were refurbished after being stored for 16 years in a member's corncrib. (Above, courtesy of Terry Snyder; below, courtesy of Paul Huscher.)

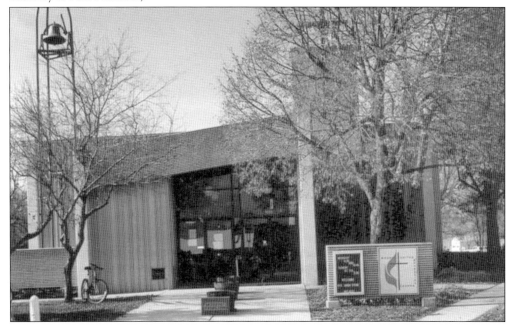

In 1918, the Catholic church's parishioners decided to erect a larger church. A building committee was formed, and 50 self-sacrificing and generous families donated $15,185 to the building fund. The church located at 250 Fourth Street in Waukee was erected for $18,000 and held nearly 200 people. Through a combination of purchase and gift from Phil and Charlotte Broderick, the parish acquired 13.26 acres located at the southwest corner of University Avenue and Warrior Lane, and in 1998, a capital campaign was initiated for the building of the new facility. The first phase of the project was completed in 2001, and the final sanctuary and parish hall were completed in January 2008. Many of the beautiful stained-glass windows that were such an important part of the earlier church were able to be incorporated into the new worship space. (Above, courtesy of Larry Phillips; below, courtesy of Terry Snyder.)

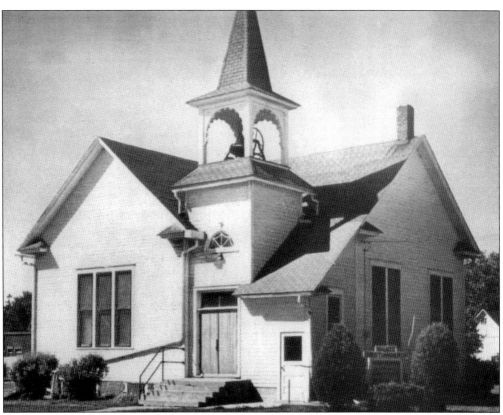

In July 1895, a group of 27 people met in July 1895 to form a Church of Christ (later changed to Christian Church) in Waukee. In the early days, services were held in Spencer Smith's opera house. In 1902, dissatisfied with the $60 yearly rent, the congregation decided to buy the lot where a creamery had stood and to build their church. The structure was erected for the $2,000 estimate. A brick educational building was added in 1965 and dedicated in 1966. This facility was sold to the City of Waukee for use as a library in 1989. (Above, courtesy of Paul Huscher; below, courtesy of Terry Snyder.)

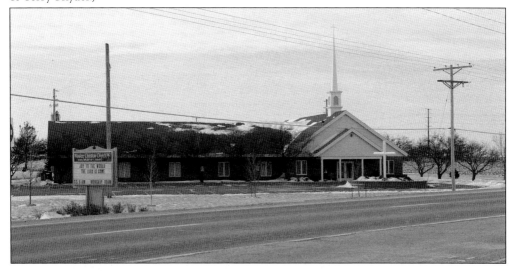

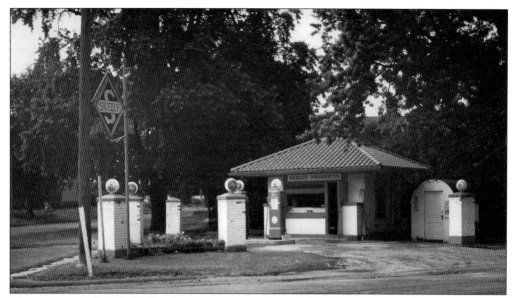

This picture of the Skelly Gasoline station was taken in the 1940s. Edward Ellsworth Shannon opened this gas station on the corner of Ashworth Drive and Sixth Street in the 1920s; it was in operation until the early 1950s, when the property was sold and a new building was erected for a grocery store. (Courtesy of Larry Phillips.)

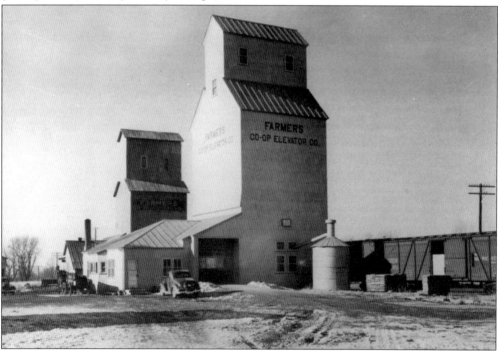

The Farmer's Elevator Company was organized in 1908. At that time, it operated Jesse Copeland's old grain elevator, east of the Minneapolis & St. Louis Railroad Depot. H.I. "Irv" Shoeman was the first manager. In 1938, the stockholders voted to change to a cooperative, with J.S. Leonard elected president and C.H. Burger as secretary. Eldon Anderson was hired as manager. (Courtesy of Larry Phillips.)

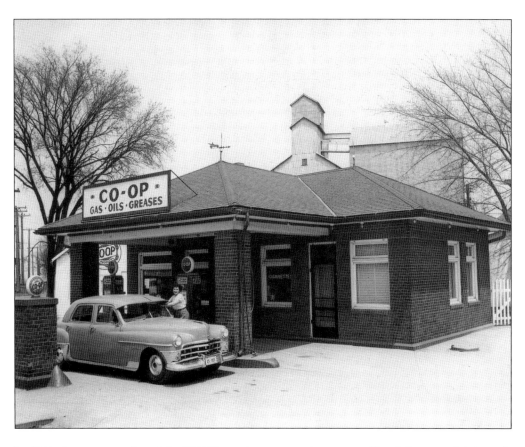

In 1944, the co-op purchased the W.P. Kent oil station on the corner of Sixth Street and Ashworth Drive, and in 1946, it purchased the lumberyard from Denniston and Partridge Company. (Both, courtesy of Larry Phillips.)

Vera (Nash) Jones is pictured on the left, with Catherine Ramsey at right. Vera ran the Jones Café in this building from 1944 to 1951. She was a lifelong resident of Waukee and graduated from Waukee High School in 1911. (Courtesy of Paul Huscher.)

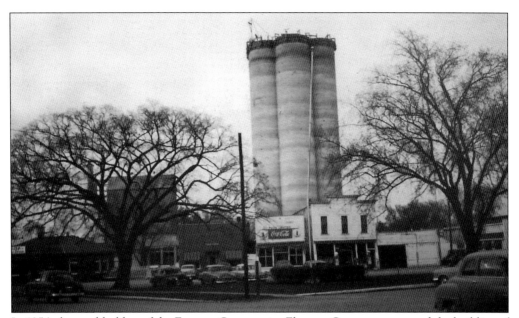

In 1956, the stockholders of the Farmers Cooperative Elevator Company approved the building of a new concrete elevator. The total cost of the elevator was $196,000, and it was built by Sampson Construction Company of Kansas. When complete, it measured 165 feet high, and it continues to be a focal point of Waukee, especially every Christmas, when one bright star lights up the top of the elevator. (Courtesy of Bob Young.)

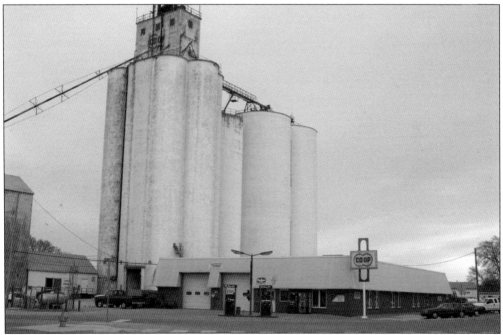

Farmer's Co-Op Elevator Company was sold to Heartland Co-op in August 2000. It continues to serve as a source for local farmers to market their grain and purchase agricultural supplies. In addition, it serves residential consumers interested in feed for pets and wildlife. As of this writing, the towering grain elevators continue to define the Waukee skyline. (Courtesy of Terry Snyder.)

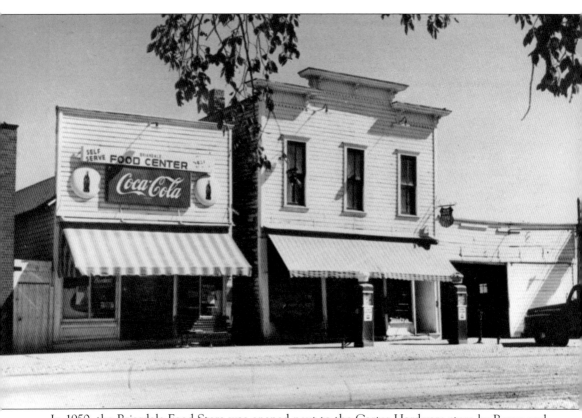

In 1950, the Briardale Food Store was opened next to the Carter Hardware store by Remo and Battista Nizzi, brothers from the Shuler coal mining community north of town. It remained in this location for three years until a new store was built on the corner of Ashworth Drive and Sixth Street, on the previous site of the Skelley gas station. (Courtesy of Larry Phillips.)

This picture was probably taken in the early 1960s. This Sinclair station, owned by Dave Smith at this time, was located on Highway 6 (Hickman Road) just north of town. The site changed hands and businesses over the years. As of this writing, Rob Shoeman's Outdoor Recreation is on this property. (Courtesy of Larry Phillips.)

In 1938, Bernard Olson opened Olson Brothers General Trucking Company south of the Triangle. In 1944, he joined the Sinclair Company, and in a few years, brothers Ronald and Mac joined him in the business. A new brick building was erected in 1954, and the business operated there until it was sold in 2008. Bernard Olson is pictured under the car, with Albina Sepich and Hiram Ori visible in the window. (Courtesy of Richard G. Ori.)

This photograph was taken on opening day in 1953 for the new Nizzi Brothers Grocery store on the corner of Ashworth Drive and Sixth Street. Owners Remo and Battista Nizzi had moved the business from its location a block away. Battista "Tom" Nizzi, is shown behind the meat counter serving a customer. The store was supplied by AG Wholesalers in Des Moines and was a full-service hometown grocery. Mary Fiori, Remo, and Battista's niece worked at the checkout. Local men would gather for a break and discuss politics and the affairs of the day with Remo. Remo and Battista, as first-generation immigrants who had worked for the Shuler mining community, understood firsthand the economic challenges that families faced and allowed customers to establish accounts to purchase groceries for later payment. The business remained at this location until it closed in 1973. (Both, courtesy of Marie Nizzi Kayser.)

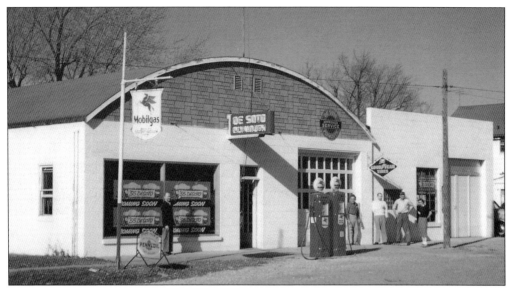

This is Waukee Motors, south of the Triangle on Sixth Street. Jake Keller bought the business in 1952 and operated it with his partner, Walter Hinkson, as a Plymouth and DeSoto dealership. Residents have recounted that this lot was used by men of the community as a croquet court prior to this business's establishment. For the last 25 years, Lyn Shafer has owned and operated Classic Floral Design in this building. Standing in front of the business are, from left to right, Keller, Hinkson, Guy Blair, and Carol Martin. (Courtesy of Larry Phillips.)

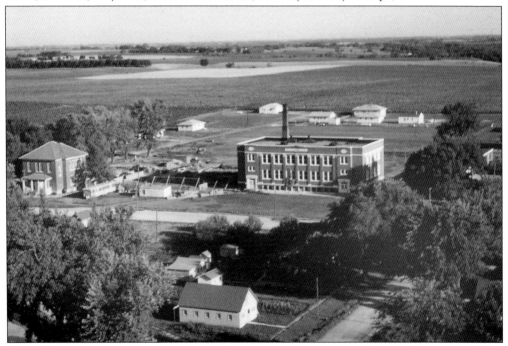

This 1956 southward aerial view captured the school and construction that had been started. The new addition was to include a gymnasium, elementary classrooms, and offices. One can see that new houses were beginning to be built southeast of the school, although there was still plenty of farmland south of town. (Courtesy of Larry Phillips.)

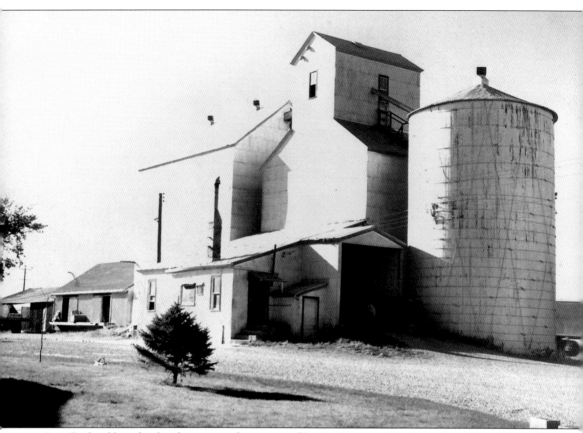

Leo Garland bought the elevator on the corner of Sixth Street and Hickman Road from Howard Dallam and established L.F. Garland and Son in 1946. The business sold feed, grain, and coal. When his son Pat returned from the war, he joined his father in the business. Leo's son-in-law Joe Wiltgen also worked with him. The family business was in operation for 30 years until 1976. (Courtesy of Chuck Garland.)

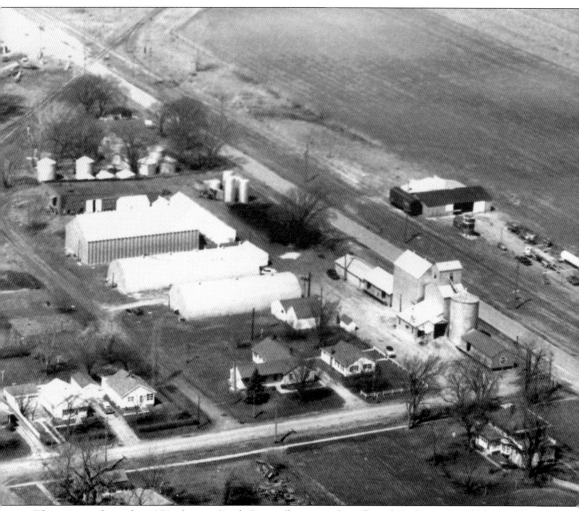

This picture from the 1950s depicts Sixth Street (horizontal road) and Hickman Road (diagonal) in a view looking toward the northwest. Garland and Son grain elevator is visible on the south side of Hickman Road. The black area just west of the elevator is coal. To the north of Hickman Road, the Baer AG Supply can be seen with the black roof. (Courtesy of Chuck Garland.)

This building on the south side of the Triangle was erected in 1940 as a locker and grocery store. It changed ownership several times over the years, but Jack Jackson was owner in the 1960s when this picture was taken. When the grocery store closed, it would be 10 years before Waukee had a grocery store again. Residents have told how the back of this building was at one time used to project community movies. They talk about "Popcorn Pete," a man who lived in a small building next door and would supply popcorn for the events. In 1989, the building was bought by Cheryl Laird Humphrey, who opened an art store. Pin Oak Gallery originally specialized in work by Iowa artists. The business operated until 2014. (Above, courtesy of the City of Waukee; below, courtesy of Terry Snyder.)

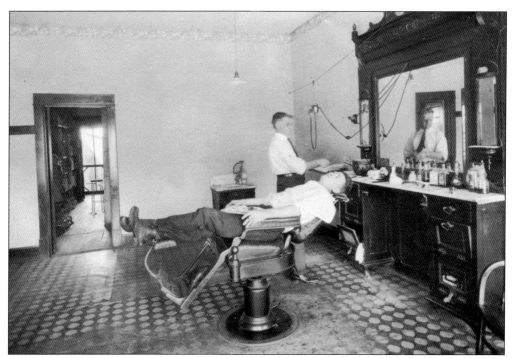

Waukee has had a barbershop in town since 1930, when William Davis purchased the building southwest of the Triangle on Sixth Street and began a business with one chair, as pictured above. The building was erected in 1918 and originally housed a dry goods store. In 1960, William Davis sold the barbershop to 23-year-old Jerry Wright for $13,000. Wright, pictured below, and his family lived above the shop for several years, and he continues to serve the community to the present day in the same location. Another barber, Doyce Blumquist, has worked with Wright since 1967. Wright also worked for the post office for 23 years as a mail carrier. (Above, courtesy of Jerry Wright; below, courtesy of Marie Nizzi Kayser.)

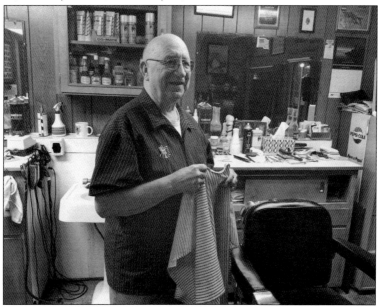

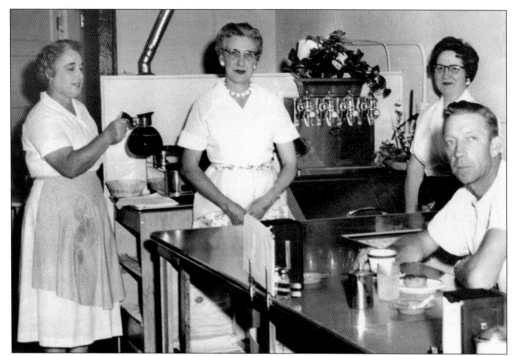

Pictured, from left to right, are Delores Abel, Laura Boone, Byna Woods, and Earl Stone on opening day of the Uptown Café in 1960. Owners Laura Boone and Byna Woods, former switchboard operators, opened the restaurant the year Northwestern Bell installed dial phones in town. They operated the restaurant for only two years, but this site continues to run as a restaurant to the present day, having undergone several changes in ownership. (Courtesy of Teresa Shoeman Broderick.)

The Golden Spur was a roadhouse located on Hickman Road owned by Jack and Tillie Jackson and George Gray. It was known for bringing in well-known entertainment from around the country. The business closed in 1996. (Courtesy of Larry Phillips.)

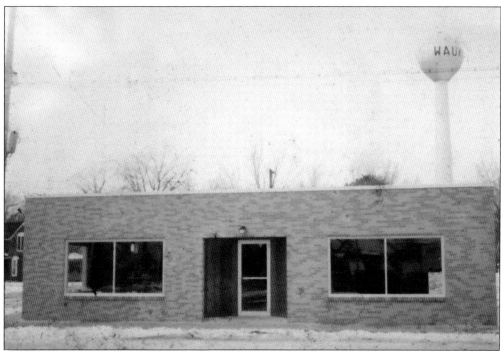

In 1960, Marguerite and Bob Jordan bought the land on the corner of Sixth and Walnut Streets and built a new store, moving their hardware business from the Carter Building north of the Triangle. Waukee Hardware is still serving the community, although it has changed ownership several times. Current owners are Ann and Geoff Warmouth. The old Waukee water tower stands in the background above. (Above, courtesy of Mark Gruber; below, courtesy of the City of Waukee.)

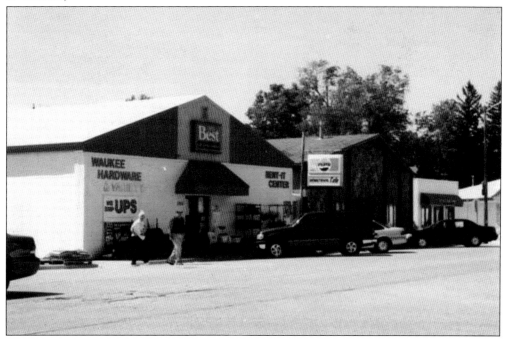

Trained at Iowa Law Enforcement Academy, Larry Phillips joined the Waukee Police Department in June 1979 and was appointed Waukee's first police chief in January 1980. In 2014, he retired as chief after 34 years. His biggest challenge was Waukee's fast growth and the lack of funds for staff and programs. But Larry realized his dream for a new police building. Raised at the Shuler Mine Camp with his parents, Ida and Bennie, and brother Ronnie, Larry spent a lifetime serving his hometown. He was a working chief who loved patrol work to meet the people and children of Waukee, and that is what he missed most after retirement. (Above, courtesy of Larry Phillips; left, courtesy of Terry Snyder.)

In September 1969, during the Waukee Centennial, two time capsules were buried under the flagpole in Triangle Park. When Waukee celebrates its sesquicentennial in 2019, the first capsule will be opened, leaving the other to be opened in 2069. (Courtesy of the City of Waukee.)

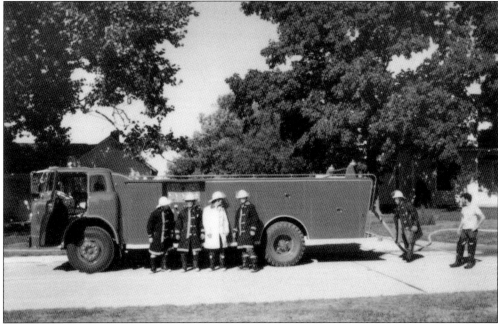

This picture from 1972 shows the new fire truck and some of the firefighters. Waukee's volunteer fire department was organized in 1938. Early fire protection was only for the corporate limits of the town and anyone living within five miles of the city limits who paid $25 for the Fire Fund. Answering a fire call outside this area cost $100. The first fire truck was ordered in 1938, and a second, in 1954. With the growing needs of the town and the possibility that the fire department would not be able to continue answering fire calls outside the city limits, a new fire truck was added in 1960. A new fire station was built in 1966. (Courtesy of the City of Waukee.)

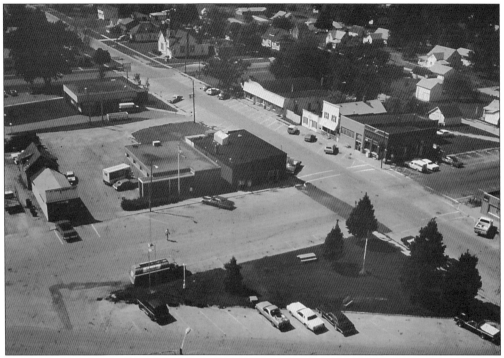

The post office is viewed on the south side of the Triangle, with the flag visible. It opened here in 1961, with Lyle Smith serving as postmaster. During Smith's tenure, from 1958 to 1987, Waukee's population grew from 500 to 2,500—from a single rural route serving 232 families and 230 rental lockboxes to two rural routes serving 1,100 families and 500 boxes at the post office. (Above, courtesy of Mark Gruber; below, courtesy of Terry Snyder.)

Fred Dluhos, a Bohemian immigrant who worked in the Shuler Mine, is pictured here installing a cistern on his property in 1954. His home is one of several that were moved from the mining camp into town. Cisterns were installed to collect rainwater, which could be piped into the home for some uses. Residents typically had a small well to pump water by hand for cooking and drinking. (Courtesy of Karen Dluhos.)

In 1954, the city dug a well at Seventh and Walnut Streets that tapped into the Jordan Aquifer. The tower could hold 50,000 gallons of water. In 1989, after a cost analysis, the city decided it was more cost effective to purchase water from Des Moines Water Works than to build and staff a water-treatment plant, which new regulations required. The tower was torn down in approximately 2000. (Courtesy of the City of Waukee.)

As early as 1878, a group of citizens with $30 worth of books started the Library Association of Waukee. Efforts made over several years to maintain a functioning library were fraught with challenges, most notably the fire of 1941, which destroyed the building and all holdings. The library opened in 1942; sometime before 1969, it moved into the back room of city hall on Sixth Street, as pictured above. Amy Hofstot served as librarian from 1944 to 1975. It is reported that the library owned 3,866 volumes. The Friends of the Waukee Public Library organization was formed in 1987 and has been key to its ongoing growth. Community support for the library was growing and can be seen in the picture below of "the wagon book brigade" moving the books one block south to a larger space. (Both, courtesy of the Waukee Public Library.)

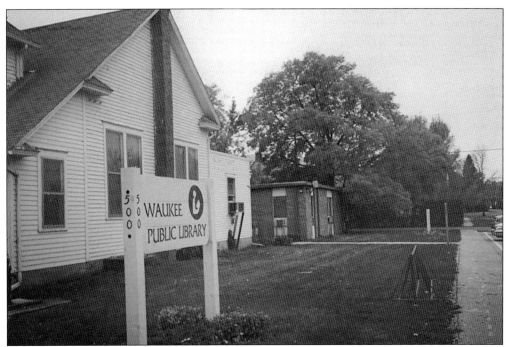

In 1990, the library moved to what had been the Waukee Christian Church. In 1992, Linda Mack was hired as the library director. The Waukee Public Library Foundation was formed in 1993 to help meet the long-term financial needs. Waukee's astounding growth spurt would soon create a demand for a larger and perhaps more permanent space to serve the needs of the community. With 89 percent voter approval, a $2 million bond issue passed in 2000. Dreaming could begin! Residents offered their ideas to Dennis Sharp of FEH Associates, who designed the stunning building that would allow for expansion as Waukee continued to grow. The Waukee Public Library on Warrior Lane opened on March 3, 2003. Currently, the library owns 60,000 items; in 2014, circulation was 165,000 items by 16,000 cardholders. (Both, courtesy of the Waukee Public Library.)

Along with the rapid growth of the city came an increased need for a recreational area. In 1969, thirty-three acres of pastureland on the east edge of town were purchased with federal aid from the Bureau of Outdoor Recreation. A contest was held to name it, and Centennial Park was chosen since it was purchased during the 100-year celebration of the city. The shelter house in the park was built by Waukee volunteers on weekends. Many organizations donated time and money to beautify the park. A cluster of three evergreen trees was planted by the senior citizens group of Waukee. The Waukee Jaycee-ettes purchased some of the playground equipment. Pictured above is a Cub Scout troop who planted trees and built and hung birdhouses. The senior citizens at left planted flowers and trees. (Both, courtesy of the City of Waukee.)

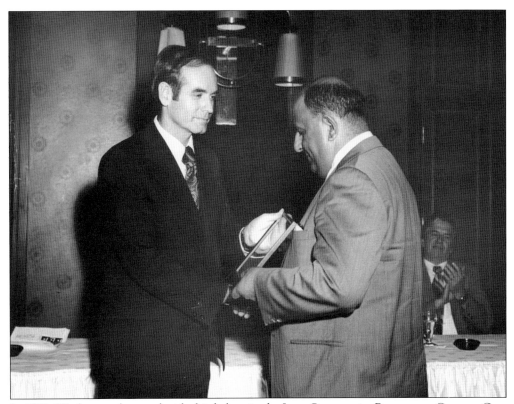

In 1972, Waukee was honored with third place in the Iowa Community Betterment Contest. Gov. Robert Ray (left) presented the award to the city, and it was accepted by city clerk Remo Nizzi. Waukee competed with communities in the 1,500–5,000 population category that were chosen on the basis of community-improvement projects. Waukee was the only central Iowa community to enter the contest, and Centennial Park was the main project. (Courtesy of Marie Nizzi Kayser.)

This picture is of the grand opening of the new Casey's General Store. The store in Waukee was one of the first three establishments that Donald Lamberti and Waukee native Kurvin C. Fish opened in Iowa with the idea of combining a service station and a convenience store. The store in Waukee was so successful that they decided to expand, targeting communities with fewer than 5,000 residents. (Courtesy of Casey's General Store.)

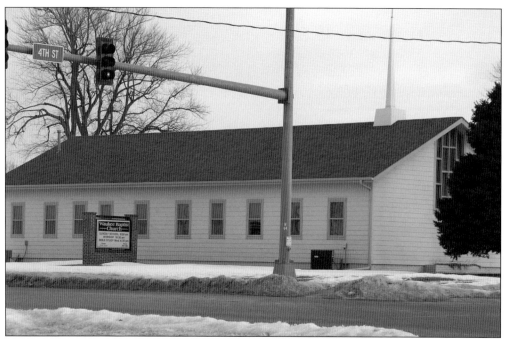

In 1973, a group met to consider the establishment of a Southern Baptist church. In 1975, an acre of land, including a house and garage, was bought at the southeast corner of Fourth Street and Hickman Road. Charles Wisner served as first full-time pastor in 1976. In 1985, a new church building replaced the house, and a year later, the steeple was placed on the church. (Courtesy of Terry Snyder.)

The Immanuel Lutheran Church congregation received a gift of four and a half acres of land from George and Corene Gray in 1976 to be used as a building site. The new church on Warrior Lane was dedicated on May 22, 1977, and Harry Peterson, its first full-time pastor, was installed on June 5. (Courtesy of Terry Snyder.)

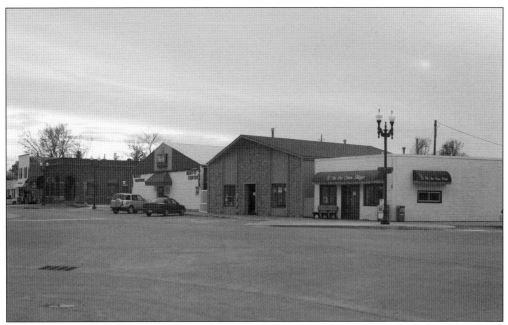

This is a recent picture of downtown Waukee, with a view facing southwest from the Triangle on Sixth Street. Notably, Waukee Hardware has been in continuous business since J.H. Carter. Waukee Triangle is the site for summer music and the farmers' market. (Courtesy of Terry Snyder.)

The Waukee Business Association was formed in the late 1980s. The nonprofit organization is dedicated to the growth of the Waukee business community and contributes to community projects. One of the association's projects has been the annual Waukee Festival, held in downtown Waukee in late summer. (Courtesy of Terry Snyder.)

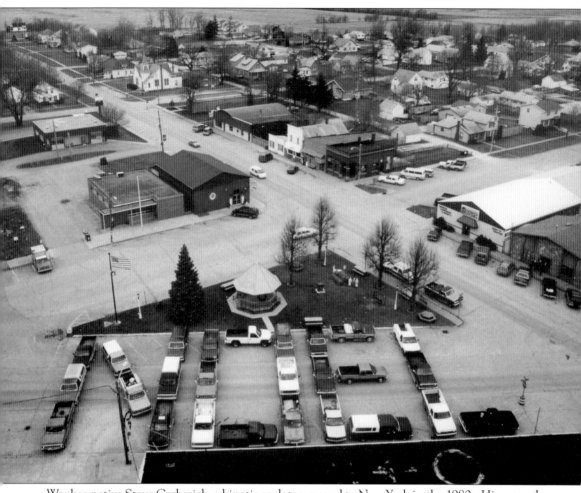

Waukee native Steve Gerberich, a kinetic sculptor, moved to New York in the 1980s. His artwork has been displayed internationally and has decorated windows in Bloomingdale's and Macy's stores. In 1993, he arranged 26 pickup trucks on Ashworth Drive and photographed this "Noel" postcard. (Courtesy of Steve Gerberich.)

Six

HOMETOWN HEROES

A hero is usually considered to be a person with distinguished courage or ability, someone who acts with conviction when needed. Such individuals are or have been admired for their deeds and qualities. Unfortunately, not all of Waukee's hometown heroes were able to be pictured in this chapter. During World War II, Waukee residents were busy with Red Cross campaigns: blood drives, bandage wrapping, and raising funds. As in the rest of the United States, rations were in place. With many husbands, brothers, and fathers drafted to Europe or stationed away from home, many women joined the workforce for the very first time. The Women's Army Corps was the women's branch of the US Army. It was created as an auxiliary unit, the Women's Army Auxiliary Corps, on May 15, 1942. This was the first war in which women could serve on active duty. The Women's Army Auxiliary Corp (WAAC), the Women Air Force Service Pilots (WASPS), and the Women Accepted for Volunteer Emergency Service (WAVES) were three branches of service for women. The major training center for the WAAC (later called the Women's Army Corp) was at Fort Des Moines. Many factories in Iowa were converted to the production of war materials. Among these were Solar Aircraft in Des Moines and the John Deere plant in Ankeny. World War II ended in 1945. The Korean War is sometimes called "the Forgotten War" or "the Bitter War Which Nobody Won." The cease-fire line was approximately the same boundary that had originally separated North and South Korea. However, communism had not been allowed to advance, and the United States had avoided an all-out war with China. In 1984, students from Harding Junior High School in Des Moines wrote a letter to Gov. Terry Branstad asking why there was no memorial at the Iowa Capitol to Korean War soldiers. On May 28, 1989, the Korean War monument was dedicated on a site south of the capitol. It is a 14-foot-tall pillar surrounded by eight 6-foot tablets that tell the story of the war.

Nathan Thorn (1832–1927) served three years in the 93rd Infantry Illinois Volunteers and received a shot wound in the leg and a broken shoulder. Nathan lived with his family in Vermont as a boy. At 28, he came to Walnut Township. After the war, he came back to Walnut Township and married Harriett Morrison Somers. They had three children—Cora, Hattie, and Nathan. (Courtesy of Marcia Blake Mills.)

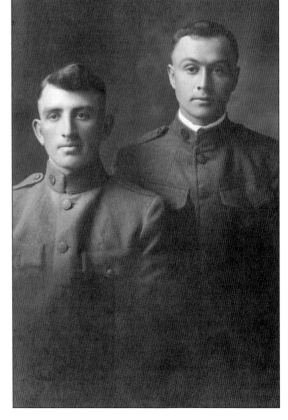

Brothers, from left to right, Harry (1888–1920) Sidney Blake (1893–1950) served their country in World War I. Sidney was in Company C, 350th Infantry, 88th Division, and Harry was in Supply Company 107th Infantry. They were sons of Robert Ross and Cora (Thorn) Blake and were raised on the family farm 2.75 miles north of Waukee, along with their three brothers and three sisters. The family has a long history of serving, starting with numerous ancestors who served in the Revolutionary War. Grandfathers Nathan Thorn and Sidney Blake, as well as great-grandfather Robert Ross, served in Union forces during the Civil War. (Courtesy of Marcia Blake Mills.)

The Jordan brothers—from left to right, Bob, Don, and Harold—are pictured here. The three sons of L.L. Jordan served in the Army Air Forces during World War II. Harold was lost while serving this great nation. In late 1957, Bob and Marguerite Jordan purchased the J.B. Carter and Sons Hardware store, which originally sat on the north side of the Triangle. While raising four children, Bob and Marguerite erected a building on Sixth and Walnut Streets and moved their hardware business to this location. Bob passed away in 1986. Don moved to California shortly after the war, married, and had three children. He owns a hardware store and is still alive today. (Courtesy of Ann Ford.)

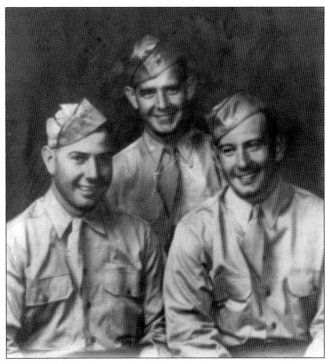

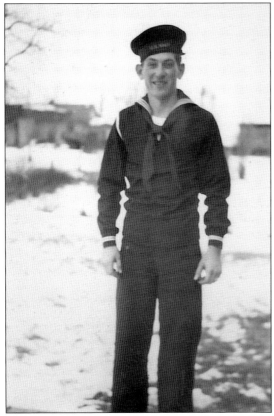

Ronald C. Smith (1920–2000) served in the naval Seabee battalion during World War II. He was the son of Carl and Anna (Young) Smith and the grandson of Charles and Sarah (McManus) Smith and Charles and Kate (Bauman) Young. In addition, he was the great-grandson of Clark and Mary (Schaffer) Smith, who were early settlers in Waukee. Clark had the grain mill a block north of the Triangle. (Courtesy of Marcia Blake Mills.)

Carroll D. Barnett (1921–2001) was a Marine in World War II. The only son of Roy and Sylvia Barnett, he was captured by the Japanese while in Guam on December 10, 1941. Carroll was reported missing in 1942. He spent four years in captivity, being held in Japan. It is reported that while he was in captivity, he would escape at night and steal vegetables from the gardens to survive. Carroll was able to come home on October 16, 1945. He was honorably discharged from the Marines on March 4, 1946. Sylvia Barnett complied seven scrapbooks while Carroll was a prisoner of war. These scrapbooks can be found in the reference section at the Waukee Public Library. (Courtesy of the Waukee Public Library and Sylvia Barnett.)

Kingsley Felt, son of Mr. and Mrs. Ray Felt, served in the Tunisia Campaign. He is pictured beside a jeep in North Africa. In Tunisia on May 18, 1943, Kingsley wrote a letter depicting his observations of a bloodstained battlefield. This letter was published in July 1943 under the headline "Dallas County Soldier Relates Experiences in African Campaign." (Courtesy of the Waukee Public Library and Sylvia Barnett.)

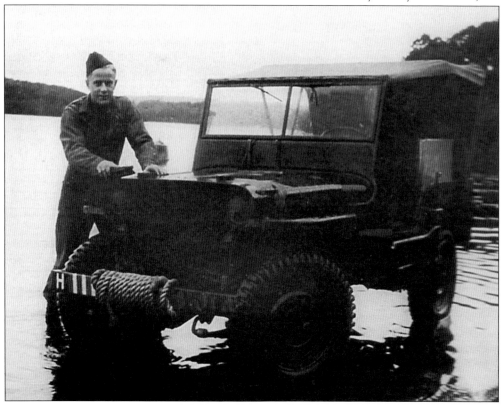

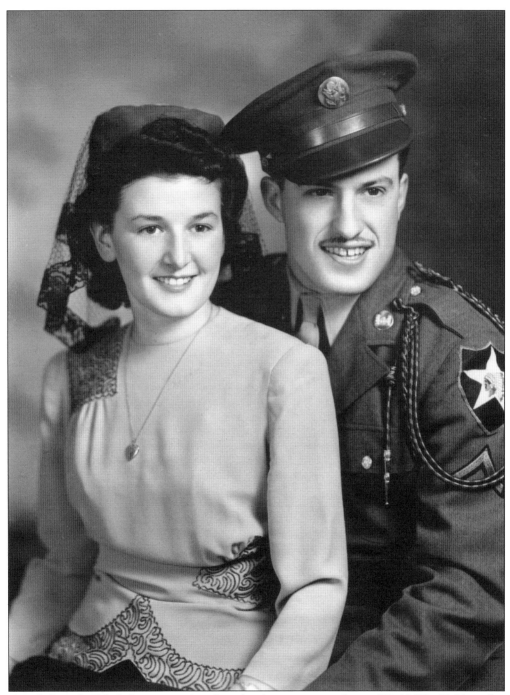

Angelo Joseph "Jake" Angaran enlisted in the Army to serve during World War II. Upon his return to the States, Jake and Lena Pedretti were married and lived in a camp house near Shuler Mine. Jake learned carpentry and was known in the community for his trade. Among Jake's contributions to the community are the construction of many new homes and the church hall, the renovation of St. Boniface Church, and the construction of the Waukee Co-Op office buildings and a pair of fourplex housing units. (Courtesy of Dena Angaran Forret.)

In all wars, women have played a role. Here, Lena Pedretti Angaran sits on top this car proudly wearing husband Jake's military cap. During the war, Lena was employed at the ordnance (ammunition) plant in Ankeny and at *Look* magazine. *Look* held a paper drive in 1944 to support Uncle Sam, and Lena hauled 125 pounds of paper from Waukee. (Courtesy of Dena Angaran Forret.)

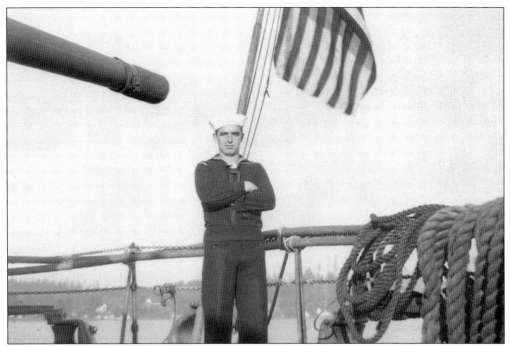

Robert "Bob" Copeland (1923–2001) served from 1944 to 1946 in World War II at an S1 rank. He chose to enlist despite his farm deferment. He attended aviation radioman training in Memphis, Tennessee, and piloted a ship-to-shore landing craft. Bob was the son of Oscar Henry and Olive Glennis (Wragg) Copeland. After the war, he married Mary Susan Keller. Until his death, he farmed north of Waukee. (Courtesy of Carol Copeland Geib.)

Hiram Ori (1923–2010) is standing to the right of Gene Autry (center) and an unidentified serviceman. Hiram graduated from Waukee High School in 1941. He spent a short time working at the Shuler Coal Mine before being drafted into the Army during World War II. After completing his World War II tour, he worked for a construction company that built the Lincoln Air Base in Nebraska. Hiram would later be recalled to serve during the Korean War. Gene Autry (1907–1998) took a break from his music and business career to enlist in the US Army Air Forces, serving as a pilot from 1942 to 1945. (Courtesy of Richard G. Ori.)

Hiram Ori and an unidentified soldier are shown here out on a walk in a nonhostile environment during World War II. The unidentified soldier is holding a Thompson submachine gun with a standard straight magazine. Hiram is holding a Thompson with a round, detachable magazine, as well as an Arisaka Japanese infantry rifle. (Courtesy of Richard G. Ori.)

Pete Guizzetti grew up at the Shuler Mine Camp. At 27 years old, the staff sergeant served with an infantry unit of the 77th Division in Okinawa. The son of Louie Guizzetti, he was killed while serving in World War II. Peter is buried at the National Memorial Cemetery of the Pacific in Honolulu. (Courtesy of Richard G. Ori.)

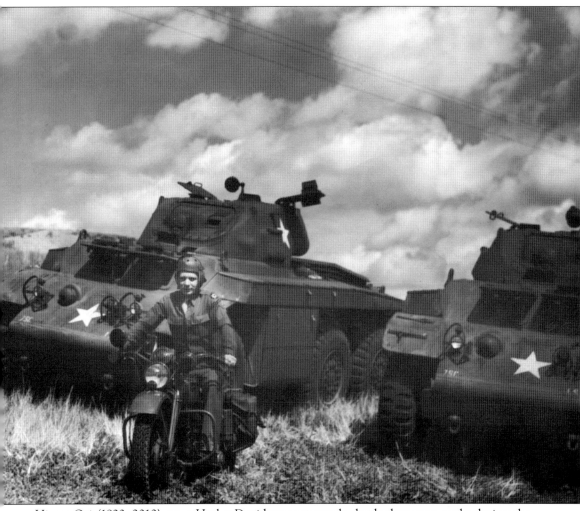

Hiram Ori (1923–2010), on a Harley-Davidson motorcycle, leads these two tanks during the Korean War. Hiram received an associates degree in engineering at the University of Colorado and worked for Coors Brewing Company until he retired. He lived in Denver until his death in 2010. (Courtesy of Richard G. Ori.)

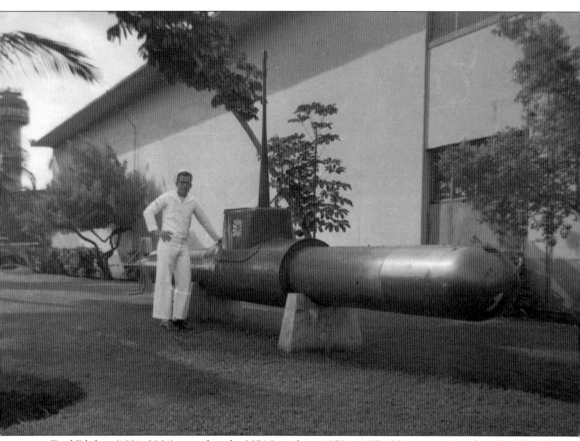

Fred Dluhos (1931–2001) served in the US Navy from 1950 to 1954. He was stationed on the island of Oahu, in Hawaii, for three years and in Washington, DC, for one year. After the service, he returned to Waukee and attended AIB College; he then began work for the *Des Moines Register and Tribune*. Fred married and had five children. (Courtesy of the Dluhos family.)

The picture of Richard Ori shown at right was taken in 1961. Richard had undergone reserved officer training at Iowa State University and was commissioned as a second lieutenant for the Air Force. He was stationed at Keesler Air Force Base in Biloxi, Mississippi, during the Cuban Missile Crisis in 1962. His training was for electronic counter warfare. He left Keesler as a first lieutenant in 1964 and returned to civilian life. (Both, courtesy of Richard G. Ori.)

Remo Nizzi (1923–1987), second from left, served in the Army during World War II. Initially, he was stationed in Pearl Harbor, then at Okinawa. He served as an Italian interpreter for prisoners of war. Upon returning from the war in 1946, he went to work for Grocer's Wholesale in Des Moines. He later opened his own grocery store with his brother in Waukee in 1950. (Courtesy of Marie Nizzi Kayser.)

Sheri "McCullough" Storm graduated from Waukee High School in 1986. She enlisted in the Army Reserves on March 25, 1987 and went to Fort Dix, New Jersey, for basic training and AIT (Advanced Individual Training) 76V at Fort Lee, Virginia. She was a sergeant attaché to 312 General Supply Unit out of the Fort Des Moines, Ames, and Creston. During Operation Desert Shield, her unit was called up but later canceled. Storm was honorably discharged from the unit after Fort Des Moines inactivated the 103rd Corps Support Command. (Courtesy of Sheri McCullough Storm.)

AFTERWORD

CITY OF
Waukee
The key to good living

Waukee was associated with the tag words "Good Living" in July 1870 when a letter appeared in the *Iowa Daily State Register* inviting people to settle in the area. The letter promised good living and prosperity. In 1973, the town council sponsored a contest to create a town emblem. Jerome Volkmer won, and over 100 years later, the tagline "Good Living" was incorporated into the emblem.

According to a 2014 study by real estate brokerage firm Movoto, Waukee is the safest city in Iowa. The city boasts seven wonderful neighborhood parks, as well as the city park known as Centennial Park and the historic Triangle Park. Waukee's active civic organizations have been participants in improvement projects around the city, so it can be said that these amenities are built for and by the citizens of Waukee. It is no wonder, then, that 2014 census data shows Waukee remains the fastest-growing city in Iowa, increasing in size at a rate of by 22.22 percent since the last Census Bureau data from April 2010.

Waukee has been preparing for this growth for over 10 years with the Alice's Road Corridor Project to connect with Interstate 80. In 2014, the Kettlestone development was announced along with the Grand Prairie Parkway connection to Interstate 80. Kettlestone is a new, 1,500-acre mixed-use development that will include an outdoor town center in a walkable environment with a variety of housing choices, retail spaces, green space, trails, and community event space.

ABOUT THE SOCIETY

The Waukee Area Historical Society was established in 2012 by the 2012 Waukee Leadership Institute Class as a class project. The group wanted to preserve the community's history and educate. A nine-member board was created. In 2013, it was designated a 501(c)(3) nonprofit organization. The current members of the Waukee Area Historical Society Board are Terry Snyder, president; Sue Ellen Kennedy, vice president; Karen Dluhos, treasurer; Jeff Longman, secretary; G. Dean Austin; Rick Huscher; Doug Dawson; Gwen Clark; and Marcia Blake Mills. Coal Mine Museum Committee members include Richard Ori and Bruno Andreini. Kristine Larson is the group's liaison with the Waukee Public Library.

The Waukee Area Historical Society's mission statement is to preserve, honor, and recognize the city of Waukee's proud history as it continues to build the foundation and values for good living for future generations. The society's website is www.waukeehistory.org.

ABOUT THE MUSEUMS

THE COAL MINE MUSEUM. The Ori Coal Mine Museum and Coal Mine Meeting Room was opened to the public on November 2, 2013. The museum houses many mining artifacts gathered from the descendants of the coal miner families. Its floor slopes down to a meeting room with timber supports to resemble a descent into a coal mine room. Two video screens give the history of the Shuler mining community and the city of Waukee. An actual coal car with coal is displayed. This car was used to bring coal to be processed from the coal rooms 350 feet below the earth's surface. At this museum, the children of the community can learn of the history of the Shuler Coal Mine and the city of Waukee. The Mining Meeting Room is entered from the museum. An overhead projector is available to be used for the presentation of information during various community gatherings. It also includes a kitchen area, which can be used for lunches. This facility was built with the generous gift from Hiram Ori, a former resident of Waukee whose father, Ernesto Ori, worked in the Shuler Coal Mine.

THE MANDERS MUSEUM. As an addition to the Waukee Public Library, the Manders Museum opened on February 22, 2009. This museum showcases memorabilia from Harold C. "Hal" Manders, who played professional baseball in the 1930s and 1940s. Manders was born in Waukee on June 14, 1917. He attended Waukee schools, was active in school sports, and graduated from Waukee High School in 1935; he then studied medicine and played baseball at the University of Iowa for three years. He was drafted as a pitcher in 1939 by the Detroit Tigers. During World War II, Manders returned home to farm with his father. In 1941, Manders married Maribelle Cross. Upon his return to the Tigers in 1946, he was traded to the Chicago Cubs, but he soon left because of a salary disagreement and his father's ill health. He farmed near Dallas Center, raising corn, soybeans, purebred Hampshire hogs, and beef cattle. Manders passed away on January 21, 2010.

DISCOVER THOUSANDS OF LOCAL HISTORY BOOKS FEATURING MILLIONS OF VINTAGE IMAGES

Arcadia Publishing, the leading local history publisher in the United States, is committed to making history accessible and meaningful through publishing books that celebrate and preserve the heritage of America's people and places.

Find more books like this at
www.arcadiapublishing.com

Search for your hometown history, your old stomping grounds, and even your favorite sports team.

Consistent with our mission to preserve history on a local level, this book was printed in South Carolina on American-made paper and manufactured entirely in the United States. Products carrying the accredited Forest Stewardship Council (FSC) label are printed on 100 percent FSC-certified paper.

MADE IN THE